# VIDEO
# REVOLUTIONS

# VIDEO REVOLUTIONS

## On the History of a Medium

MICHAEL Z. NEWMAN

Columbia University Press

New York

Columbia University Press
*Publishers Since 1893*
New York    Chichester, West Sussex
cup.columbia.edu
Copyright © 2014 Columbia University Press

All rights reserved

Library of Congress Cataloging-in-Publication Data
Newman, Michael Z.
  Video revolutions : on the history of a medium / Michael Z. Newman.
    pages cm.
  Includes bibliographical references and index.
  ISBN 978-0-231-16951-6 (pbk. : alk. paper) —
  ISBN 978-0-231-53775-9 (ebook)
 1. Video recordings—History.   I. Title.
 PN1992.935.N49 2014
 302.23′4—dc23

                                                                                             2013046909

∞
Columbia University Press books are printed on permanent and durable
acid-free paper.
This book is printed on paper with recycled content.
Printed in the United States of America

p 10 9 8 7 6 5 4 3 2 1

Cover design by Jason Alejandro
Cover art by Hollis Brown Thornton

References to websites (URLs) were accurate at the time of writing. Neither the
author nor Columbia University Press is responsible for URLs that may have
expired or changed since the manuscript was prepared.

# CONTENTS

Preface  vii
Acknowledgments  xiii
1. Three Phases  1
2. Video as Television  7
3. Video as Alternative  17
4. Video as the Moving Image  73
5. Medium and Cultural Status  95
Notes  107
Select Bibliography  121
Index  131

# PREFACE

As a detour sometimes becomes a trip of its own, this book, which I also think of as a long essay, came into being while I was on my way somewhere else. The place I was going was research on early video games and the emergence of that new medium. I am young enough not to remember the earliest games of the 1970s, so it was news to me that when they came along they often were called TV games. This made me wonder why eventually they came to be known as video games rather than as TV games, and what if any difference that represented. As I came to appreciate, video often stood for something rather distinct from TV in the 1970s—but wasn't video also a synonym for television? How could the same word be both a synonym and a term of distinction? It was this series of mini-discoveries and semantic puzzles that led me toward *Video Revolutions*, which aims at once to account for the variety of meanings video has had over time and for the ways in which the concept and category called the medium functions to accommodate this kind of ambiguity and diversity of reference and meaning.

To some extent, then, this book traces the history of a word. Words name things, but they also have their own lives. The word *video*'s life has been shaped by the things it has named, but not only by them. Such objects, and the ways we use and understand them, have also been shaped by the terms and ideas through which we have named and imagined them, fixed them in their identities though never too securely. So if this is the story of a word, it is also necessarily the story of the things and ideas with which the word has been joined together or from which it has been split apart over the many decades in which it has been in common currency. A word is not the same as a medium it describes, but neither are these two concepts very easily separated, as a medium is a cultural category, and culture is produced through language. A medium is not just technology, as a number of scholars have pointed out. It is also a way of thinking about and using technology, a cluster of conventions practiced within a set of social relations.[1]

Video has been the name for a particular kind of thing: electronic technology. As has been true of the telegraph and telephone, electric power and light, and digital computers, video has often been understood and imagined through a prevalent way of thinking about modern technology and society. This way of thinking goes by several names. Carrying forward Leo Marx's idea of the industrial-era mechanical sublime, James Carey and John Quirk identify the electrical sublime that runs from the telegraph through the computer age, conveying a utopian mythos of redemption through technology.[2] Thomas

Streeter refers to a blue skies discourse of the new technology in his discussion of cable television in the 1960s and 1970s and its potential to open up mass media to society's benefit.³ Vincent Mosco speaks of the myths of cyberspace in terms of a digital sublime, particularly as these myths promise to overcome the challenges of time, space, and politics.⁴ And Evgeny Morozov dubs the reigning ideology of twenty-first century Silicon Valley technological solutionism, the belief that society's problems can be ameliorated by the new products of high-tech start-ups.⁵

Distinct historically and conceptually as they are, these ways of thinking share a number of traits. They describe a quasi-religious faith in electronic technology as an impetus to societal improvement, a great benefit to humanity pointing the way to a future free from the problems of the past and present. In its many iterations, this utopian rhetoric repeatedly returns to the idea of revolution. A revolution is not merely a change but an upheaval. To use 2010s tech lingo, a revolution is a radical disruption of the status quo. Owing to the term's historical political connotations, revolutions are closely associated with independence and liberation. To revolutionize, observed Raymond Williams, is to produce "a new social order."⁶ A revolution gives power to the people and moves the world forward.

Video revolutions are but one patch of a broad field of new technologies promising revolution. Along with video revolutions have come revolutions in computers, convergence, networks, mobile devices, and on and on, all under the umbrella

of the information revolution. One ideological function of revolution talk is to displace political, economic, and cultural structures that produce and reproduce our most intractable problems and substitute technological fixes for the more challenging and difficult work that would move us toward changes most deeply desired and needed. Revolution talk also functions to shift interest from the objectives of powerful institutions and individuals, who benefit from the commercial fortunes of media and electronics, to the people whose interests are supposedly to be served by technological improvement, and whose participation in technological innovation as enthusiastic consumers is often necessary to satisfy the objectives of corporations and states. Revolution talk bathes media and technology in a glow of optimistic promise and thrill, but it is typically devoid of authentic critical perspective or historical understanding.

I am mindful of how these power dynamics underwrite our ideas about new technology in particular as they inform my own thinking about scholarly writing in a time of e-readers and multiplying screens. As I type, there is supposedly a revolution going on in the world of books and writing easily as momentous as the video revolutions that are my topic. This promises to disrupt the status quo of academic publishing no less than any precinct in the production of letters. I originally conceived of *Video Revolutions* as an electronic text, with the idea that an essay of this length and scope would be too lengthy to publish as an article or book chapter, but too brief to publish as a conventional academic book. I saw the experimental form of

the e-book short or single as potentially liberating, opening up a nice medium-size option between two extremes. There was perhaps a bit of technological solutionism in my mind (maybe to compensate for my ignorance of how book publishing actually works). One cannot stand fully outside of ideology even to critique it, and I am hardly immune from the thrill of utopian tech fetishism. As I have tried to show in *Video Revolutions*, however, often what seems boldly new is actually just something old slightly modified and made over—as Apple's product designer Jony Ive puts it, technology that "feels familiar and yet is new at the same time."[7] Scholars were writing both short books and extended essays long before E Ink and touchscreens were everyday objects. We might think of an academic book having certain expected qualities of length, shape, and scholarly apparatus, but nothing about the technology of the book— print or electronic—demands any terribly specific conception of its contents. I wonder if we would do better to think (to the extent that this kind of thinking is possible) less of books, articles, blogs, etc., and more of writing, argument, and ideas. One of the ideas I have tried to suggest in the pages to follow is that a medium is often more flexible and labile than prevailing notions about it seem to allow. Trying to fix a medium with one clear identity and purpose is ultimately never going to work because the intertwined history of society and media technology is one of regular change, renewal, and remediation. This insight should apply as much to media of writing as it does to media of sound and moving image.

## ACKNOWLEDGMENTS

A number of friends and colleagues have aided the progress of this book from idea to writing and revision to publication. I am thrilled to have worked again with Jennifer Crewe, an editor who was eager to pursue an unconventional project and saw the value of trying new things. I began the research that developed into this work while on a fellowship at the Center for 21st Century Studies at the University of Wisconsin-Milwaukee, and I am grateful to the Center for its intellectual community and commitment to interdisciplinary humanities scholarship. Zach Campbell, Peter Collopy, Kit Hughes, Josh Kitching, Richard Popp, and Ira Wagman offered excellent advice, expanded my understanding, pointed me to sources I didn't know about, and sometimes saved me from blunders. Philip Sewell was particularly enthusiastic, and his media history knowledge has been indispensable. Columbia University Press's anonymous reviewers offered outstanding feedback, and this work is undoubtedly much better for their generous,

knowledgeable, and incisive comments. Finally, I never would have found myself writing about the history of video if not for Elana Levine, a constant source of support and inspiration. Thank you all.

# VIDEO
# REVOLUTIONS

# 1
## THREE PHASES

**As tube,** tape, and disc are replaced by file, pixel, and cloud, the present moment in media history offers a vantage point for regarding *video* as an adaptable and enduring term that bridges all of these technologies and the practices they afford. At different times video has been different things for different people, and its history is more than a progression of material formats: cameras, transmitters and receivers, tapes and discs, decks that record and play them, digital files, apps and interfaces. It is also a history of ideas about technology and culture, and relations and distinctions among various types of media and the social needs giving rise to their uses.

Champions and detractors have projected onto video a succession of fantasies, both positive and negative, at various moments of its history.[1] Like television, video has been perpetually renewed, reborn as new media in relation to older

iterations made obsolete by the relentless forward march of technology. It is something of a law of new media that emerging technologies are regularly invested with their users' hopes and fears, with expressions of their societies' tensions, contradictions, and crises.[2] I aim to represent a history of video that accounts for these expressions in their specific contexts from the early period of television to the present day, identifying three broad historical phases. These phases are marked by technological innovations such as videotape and streaming web video, but also by the ways in which video has been placed in relation to other media, including radio, television, sound recording, and film, as well as networked computers, their hardware and software.

In the first phase, the era of broadcasting's development and penetration into the mass market, *video* was another word for *television*. The two were not distinct from each other. In the second, TV was already established as a dominant mass medium. Videotape and related new technologies and practices marked video in distinction to television as an alternative and solution to some of TV's widely recognized problems. It was also distinguished from film as a lesser medium visually and experientially, though at the same time it was positioned as a medium of privileged access to reality. In the third phase, video as digital moving image media has grown to encompass television and film and to function as the medium of the moving image. These phases are defined in terms of their dominant technologies (transmission, analog recording and playback,

digital recording and playback) but more importantly by ideas about these technologies and their uses and users.

*Video Revolutions* is concerned with outlining the phases, but it also offers the example of video history as a way into reconsidering the idea of a medium as such. I propose adopting a particular understanding of this concept, a cultural view. From this perspective, a medium is understood relationally, according to how it is constituted through its complementarity or distinction to other media within a wider ecology of technologies, representations, and meanings. A medium is, furthermore, understood in terms not only of its materiality, affordances, and conventions of usage, but also of everyday, commonsense ideas about its cultural status in a given historical context. Cultural status refers to the ways in which a medium (or any cultural category or artifact) is valued or not valued, made authentic or inauthentic, legitimate or illegitimate.[3] The medium of video exists not only as objects and practices, but also as a shifting constellation of ideas in popular imagination, including ideas about value, authenticity, and legitimacy.[4] We can apprehend video's materiality and its significance only through the mediation of discourses of video technology and the practices and social values associated with it.

I will be most concerned in my discussion of video's three phases with describing and explaining each way in which video has been understood historically, particularly in terms of cultural status. When video was synonymous with television, its cultural status was television's cultural status. When video was

distinguished from television, its cultural status was opposed to television's, unless it was associated with TV rather than with the movies that were the content of videotapes offered for rent at video stores. And as video has become a category bigger than either movies or TV, its cultural status has still been the product of enduring ideas about these media and their value and legitimacy. In my conclusion I will return to a more abstract discussion of the medium as a concept, elaborating on the examples offered from video history and extracting higher-level meanings from them.

In considering video's history I have relied in particular on sources that speak to the ways in which people have understood popular media and culture. Reading the popular and trade press and the writings of prominent intellectuals and looking at advertisements and newspaper or magazine illustrations does not give us direct access to anyone's thoughts, but it does establish a horizon of meanings available to individuals and communities in a particular place and time. It also shows us what some dominant meanings were, and how powerful interests tried to assert particular kinds of values and ideals. It is these dominant and typical available meanings that most interest me, as they speak most directly of video's cultural status.

One key insight throughout will be the centrality of one medium in particular in relation to video. No matter whether video has been associated with television or distinguished from it, TV's cultural status has often been the most important factor for understanding video. Television's place as society's

dominant medium, and its shifting fortunes over time, will never be far from the surface in the events to come. Since television's ascent to mass medium status, all media have been in some ways defined in relation to it. In the next chapter, the story begins with video and television sharing an identity in a period of optimism and hope for the future of communication, broadcasting, and the moving image.

# 2
## VIDEO AS TELEVISION

**When television** was new, the term *video* distinguished it from *radio*, a similar sounding word, out of which television grew as a commercial medium of broadcasting, and against which it was understood as a technological improvement. In the 1940s and 1950s, TV was synonymous with video, and the five-letter word fit well in newspaper headlines, where it often appeared in stories about broadcasting. This persisted for several decades, though the peak of interchangeable usage was in the early 1950s, as Google's Ngram for *video* in American English sources suggests. Video's bump in the early 1950s coincides with the emergence of TV as a mass medium. (The upward slope beginning in the later 1960s suggests that the term gained wider usage later on when it would distinguish video recording from live television broadcasting; fig. 2.1.) The *New York Times* broadcasting column in these early days of TV was

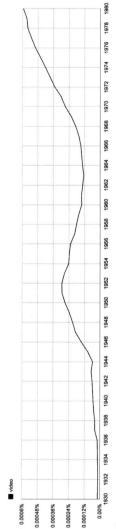

FIGURE 2.1 Google's Ngram for *video* (case sensitive) in English from 1930–1980.

called "Radio-Video." Articles in the popular and trade press would use *video* the way we might today use TV, referring to video cameras, video stations, video sets, video studios, video personalities, video programs, video technique, and video audiences. When sponsors left radio for television in the early 1950s, the news reported this in terms of "video's impact on radio."[1]

Video in this phase was not only distinct from radio but also parallel to it. Radio referred to the transmission of sound via electromagnetic waves to receivers, most typically in the home in the case of commercial broadcasts. Video did the same thing, using similar technologies (e.g., transmitters and receivers), but with pictures. Orrin Dunlap's 1932 volume *The Outlook for Television* notes that the vision half of the word *television* comes from the Latin *video*, "I see."[2] The earliest quotation in its *OED* entry, from a 1937 issue of *Printer's Ink Monthly*, defines *video* as "the sight channel in television, as opposed to audio." Thus the substitution of *vi* for *ra* in the words *video* and *radio* indicate a common meaning of instantaneous communication across significant distance of an electronic signal, and of commercial broadcasting. Calling the television a *set* indicates an aggregation of technologies, and video reception and display was one of these.[3] At the time of TV's introduction to the consumer market, the *New York Times* described how television works by explaining that the "video component" of a TV signal was composed of the broadcast of scan lines beamed by an electron gun. This would be joined by a sound channel, as in radio, a separate signal from the image or video channel.[4]

Television's cultural status in its early years was a product not only of how TV was made and watched but of the hopes for the new medium and its idealization as a technology with the potential to overcome some of the deficiencies of existing media. Most centrally, the ideal of television was as a medium of immediacy and directness, making possible the instantaneous transmission of events bringing widely dispersed audiences together. Because of its place in the home and the size of its screen, and because of its status as an improvement on radio, television was regarded as an intimate medium capable of conveying honest and true representations to the individual viewer. And because of its addition of image to sound, television was seen as the culmination of decades of technological effort to transmit events live from one place to another, making possible a form of communication distinct and in some ways more impressive than earlier forms such as theater, movies, and radio. The fact that television's picture was regarded as wanting in comparison to cinema's helped promote the newer medium's liveness and immediacy as particularly televisual aesthetic virtues.[5] Early television was thus understood in relation to these forms in particular, and often in rather techno-utopian terms. Gilbert Seldes claimed in 1950 that by combining "sight and sound immediacy" with color and eventually stereoscopic images, TV promised to become a "platonic ideal of communication."[6]

The techno-utopian connotations of television were among the meanings associated with the new medium in *Captain*

*Video and His Video Rangers*, a notable early television program, which aired nightly at 7 P.M. on the DuMont Network from 1949 to 1955. A science fiction series broadcasting live on a modest budget, *Captain Video* might often be remembered as much for its laughably cheap production values and its commercial appeal to children as a market for tie-in merchandise like space toys and apparel as for the ideas it expressed about the video medium. But as David Weinstein argues, *Captain Video* represented post–World War II ideals of belief in the application of scientific knowledge as a way of overcoming the devastating military struggles of the past, represented in the figure of the Captain as a space explorer and fighter.[7] By naming the character after the medium on which he appeared, the show's creators were not merely establishing an identity for Captain Video as a TV personality and drawing on the novelty of TV. The *Video* in his name also spoke of the potential for television to be part of a new world of scientific progress and exploration. In these years when television was new enough to be considered magical, like something out of the world of science fiction, TV representations of space and of the futuristic gear of space travel (actually refashioned from Wanamaker's department store stock such as automotive parts) implicitly conveyed the medium's power to overcome old limitations of time, space, and vision. Within the narrative of the program, Captain Video communicates via an antenna atop his house, employing one tool called the "opticon scillometer," a telescope-like device that gives him the power to see any and all things,

and another called the "remote carrier beam," a display resembling a TV set that permits communication with his agents in remote locations. Video, as repurposed in this representation, was not merely an improvement on radio but a revolutionary and futuristic technology leading toward human achievement and progress. Its power of making seen the unseen and connecting people across vast distances was connected to its mission of establishing institutions of commercial broadcasting, which was the ambition of early networks such as DuMont. Thus liveness and associated ideals promoted as TV's essential qualities were not merely technical descriptions but also expressions of hopes for a new technology growing alongside hopes for postwar society.

These ideals were also figured in relation to other media and their institutions, typically understood in terms of their own social implications and the anxieties associated with them. The liveness and instantaneity of TV gave video its earliest identity, and it was one constructed in opposition to the dominant mass medium of entertainment in the years leading up to TV's introduction: the movies, which meant Hollywood. As William Boddy has shown, critics of the early 1950s regularly opposed television's aesthetics with cinema's, and the contrast was based not only on technological criteria but also on the reputation of the movies and the American film industry.[8] In the account of cultural elites, Hollywood was characterized by its cynical assembly line production of mediocre entertainment for an undiscerning mass audience. Television, they hoped, would

do better by avoiding the conformity and commercialism of the movies and upholding a higher artistic standard in its programming. Video was idealized in terms of cultural uplift and improvement, of escaping some of the deficiencies of the most popular commercial entertainment of the day. The location of the broadcasting industry in New York rather than Los Angeles and the model of theatrical naturalism that television would borrow from the legitimate stage were factors in the hopeful intentions of critics and network programmers to distinguish the new medium and make clear its aspirations to greater cultural legitimacy. RCA's president David Sarnoff proclaimed that "television drama will develop in novel directions, using the best of theater and motion pictures, and building a new art-form based on these."[9]

The idea that television's essence would be its live broadcasts was worked out especially in tension with the use of recorded (i.e., filmed) rather than live programs on the TV networks in the early and mid-1950s. The idea of live broadcasting's superiority, and its status as the essence of broadcasting, carried over from radio practice. Before television's ascent to mass medium status, the radio networks placed a stigma on recorded programming, and quarreled with talent, most famously Bing Crosby, over the issue.[10] But radio networks did often use electrical transcriptions, the sound-on-disc recording format that preceded magnetic tape, for broadcasts of recorded programs (including Crosby's, the first regularly scheduled recorded network program), and many stations relied on them extensively.[11]

Beginning in the 1920s, however, the most powerful interests in radio had established live and simultaneous national network broadcasts as the most legitimate use of radio, what Alexander Russo in his historical account describes as "the best and most natural form of the medium."[12] Recorded programming was sometimes banned and sometimes regarded as fraudulent. Radio stations announced when recordings were being broadcast to make clear that they were not live, reinforcing a norm and an ideal of liveness. This served the interests of the national networks, who alone had access to technology (AT&T's network of lines spanning the continent) enabling national live broadcasting.

The elevation of live over filmed television broadcasts was one of many ways in which television carried on practices established in network radio in the 1920s, 1930s, and 1940s. Television critics in the early 1950s considered filmed TV shows to be aesthetically inferior to live teleplays and elevated the live anthology drama, with its big-name writers of New York theater backgrounds, as the model of artistic achievement for the medium. It was on these terms that the notion of the 1950s as a golden age of television was established. Like radio, however, much of television at this time was made up of broadcasts of recorded programs. Film and later tape eliminated the unpredictability of live television (including live ads), allowed for the tricks of cinema such as miniature, slow motion, and process shots, and better accommodated shooting on location and changing sets and costumes. With film, a TV show could

be "planned, rehearsed, staged, edited, previewed and telecast with professional perfection."[13] By the 1960s the live drama had been cast aside by new formats that were more economically rational for producers, networks, stations, and advertisers.

Still, the identification of television's purpose and essence as live transmission has endured long after that period, becoming a founding myth and abiding ideology.[14] A plaintive *New York Times* story in 1978 about the shift of many genres of live television such as news, sports, and talk shows from live production to videotape insisted that "the best television has always been live television."[15] Writing in the early 1980s, John Ellis claimed that the television broadcast image generally appears as if immediate and live, particularly in comparison to cinema, even in genres such as soap opera that make no overt claim to liveness. "The notion that broadcast TV is still live haunts the medium; even more so does the sense of immediacy of the image," Ellis argues. He describes this immediacy as a "sense of the perpetual present."[16]

The video medium in the 1950s was in a period of establishment, wherein critics and networks were working out ideas about values of the technology and its uses in relation to other media of the time. Jack Gould, the *New York Times* TV columnist and among the period's most respected elite critics, railed against the networks' use of recorded programming, calling the choice to rely on such fare a "colossal boner." Under the headline "A Plea for Live Video," he reasoned that filmed programs had a diminished picture and sound quality, and that

they were lacking in a "trueness" that is the "heart of TV." Previously recorded programs aimed to be little more than a lesser version of what one might find at the neighborhood cinema, but live video—"true television"—would offer "the intangible excitement and sense of anticipation that is inherent in the performance which takes place at the moment one is watching."[17]

The liveness of television, as Elana Levine writes, has often been used to distinguish different kinds of TV programming in terms of their aesthetic quality. Ideas about the ontology of video images and their transmission have often been caught up, she argues, in "struggles over distinction and cultural worth that have long been part of television history."[18] The identity of a medium is often tied to the status of its most highly valued examples, as was clearly the case in the early years of TV as a mass medium. The identification of liveness as the essence of video would soon give way to quite different conceptions of the video medium as technological and cultural changes prompted revisions to its status, to the functions and meanings ascribed to it, as the next chapter will show. But in its initial stage, the live transmission of images was central to video's identity and to the work of distinguishing television from other media.

# 3

# VIDEO AS ALTERNATIVE

**Beginning in** the later 1950s, a new technology of moving image recording emerged. Magnetic tape had already been in use for recording sound during World War II, and innovations in magnetic recording led to the production of videotape recorders or VTRs, the first of which were brought to market for industrial use by the Ampex Corporation of California in 1956.[1] Television production in the 1950s used kinescopes to film the video image off a monitor for archiving and for delaying or repeating broadcasts. Kinescopes had several disadvantages in comparison to the new videotape when used in broadcasting. Their image quality was noticeably degraded compared with live television pictures, passing from "electricity to optics to chemicals to optics and back to electricity again."[2] Kinescopes were many times more expensive than videotape, and films required time and chemicals to process in a laboratory before

they could be used. Tape could be reused many times but not films. And videotape when broadcast would look identical to live television. It was described in the press as a "miraculous ribbon," and its effects were described as a "revolution, technical and artistic, in the industry"[3] (fig 3.1). American television networks had a particular need for videotape as a solution to the problem of a national audience dispersed across four time zones. Live programming at eight in the evening in New York would be airing at five in Los Angeles. Videotape would solve this issue and allow for the delay of broadcasts to reach the prime time audiences in all markets without the need for "hot kine" broadcasts using hastily processed strips of film, 35mm for picture and 16mm for sound synced in playback, which could be destroyed by a single use.[4] CBS used tape for delayed programming in some instances in 1956, and beginning in 1957, NBC's West Coast broadcasts were entirely tape delayed in prime time.[5] The audience might not even know about the delay and assume it was seeing a live image.[6]

Between the later 1950s and the emergence of digital video as a mass market format in the late 1990s, video shifted its meaning from being synonymous with television to denoting an alternative to conventional television transmission and reception using its technology against the purpose of live broadcasting. This usage encompassed video cameras and recorders, whether employed by artists creating video art or by ordinary people making home videos. It also encompassed video games and video recordings of TV shows to be watched at the user's

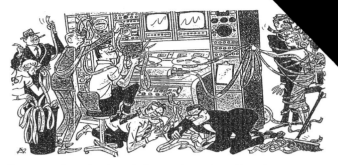

Figure 3.1 The novel medium of videotape, a "Miraculous Ribbon of TV," as described and illustrated by Abner Dean in the *New York Times*, June 18, 1959.

convenience, often skipping commercials, or commercially released movies to be viewed on TV sets. In this second phase, new usages of the term emerged. *To video* meant to make a video recording. A video was a recording on tape. At times there was some overlap and confusion about terminology, for instance when a headline in *Broadcasting* asked, "Is TV Tape Live or Film?"[7] To this day, people will refer to recording in any kind of moving image format as "filming." But filming and taping were technologically distinct, and film and video were considered two different, though related, media, each one having not only its own qualities of image and techniques of production and distribution but also cultural associations and shifting connotations of realism and quality. Each one had its own aesthetics and style. An advertisement for Ampex products in the trade journal *Sponsor* in July, 1958, insisted that "videotape is a new medium" but also "an extension of live television," seeking distinction from film. Over several decades these distinctions

adapt, as video was understood by affinity se neighboring media.

television began their convergence, the relaio was largely lost, however, and video came a recording and playback and less as a transmitting and receiving medium. At one moment, however, radio resurfaced as a frame for understanding video: when MTV was seen to be at once borrowing from and threatening radio, with its video jockeys and its "format" in place of the conventional TV schedule. The historical significance of "Video Killed the Radio Star" as the first music video aired on MTV speaks to this ambivalent remediation.)

The new meanings for video in phase two included ideas about the media audience's relationship to technologies and institutions. Video promised to liberate and empower viewers and to democratize mass media. These meanings would have as much to do with prevailing conceptions of the commercial broadcasting industry as with the actual uses and needs of television and video's users. Following the golden age period, the early sense of television's aesthetic promise was largely lost. Its cultural status as a vast wasteland, as FCC Chairman Newton Minow famously called it in a speech given in 1961, was solidified following the quiz show scandals of the late 1950s and the decline of the live anthology dramas as commercialism was seen to triumph over art. In 1959 Walter Lippmann called the television industry fraudulent and evil not only for the deception practiced on quiz shows but for betraying the public

interest by pursing profit before all else and thereby debasing public taste.[8] Television in these years was widely derided for pandering to a mass audience and serving commercial rather than civic interests. Its detractors feared that television was becoming not just a waste of time and technology but a source of individual and social problems. One of a number of anti-TV books published at the time was called *The Great Time-Killer: A Documented Indictment and Constructive Study of Television, the Mind-Seduction Machine.* In popular imagination, video was figured as the revolutionary solution to many of the perceived problems of television, in particular to the sense of television's economic and ideological power over its audience and the society it was understood to be shaping. Video might save the medium and reverse its decline.[9]

Today some might think of the history of home video beginning with the release of the Sony Betamax in the mid-1970s, but broadcasters, artists, and many others had been making use of videotape for almost two decades by this point. The general public was aware of videotape long before it became a widely adopted consumer product for the home. Innovations in electronics and communications were regularly described and reported on in the popular press and demonstrated in public. Hundreds of news items described videotape in the later 1950s and its use by television networks and stations around the United States, explaining the advantages of the new technology and its likely uses. Ampex exhibited its wares in Grand Central Terminal in New York in 1958, attracting the notice of

the press.[10] It also advertised its brand and product in revolutionary terms, in one instance comparing the invention of videotape to Einstein's theory of relativity.

Before it was a consumer technology, videotape was in use in a variety of contexts other than television production, where many people outside of the broadcasting industry might come in contact with it. In the later 1960s, the *Chicago Tribune* reported that videotape was widely used in "education, industry, sports, business, medicine, and even the military." By 1968 there were more than 20,000 VTRs in use in the United States, compared with 5,000 being used in the TV business.[11] The National Education Association published a how-to book in 1968 entitled *Portable Video Tape Recorder: A Guide for Teachers*, detailing myriad uses and techniques including enhancing demonstrations, overcoming distance, repetition of materials, and producing creative work, as well as advantages in comparison to educational film.[12] Often tape complemented or replaced closed-circuit television in industrial, medical, or government use for training and communications. A California retail chain used a videotaped sales presentation to demonstrate its new lines of products to salespeople in sixteen stores, while a gas company in Ohio used videotapes to train its customer service force of 800 employees.[13] The Iowa appliance firm Maytag used videotape to record its sales personnel practicing their pitches for instant review and improvement, among other training purposes.[14] Even consumer-grade video was often used in industry. Sony's U-matic videocassette recorder was first sold

to consumers in 1971 (earlier formats used open reels), but like most such ventures before Betamax did not catch on with the public. However, the technology was adopted in institutional settings. The Ford Motor Co. bought 4,000 U-matic machines in 1972 to use in training automobile dealers.[15] As a new technology, video recording emerged as the solution to problems of earlier technologies such as film, or as an improvement over doing things without the benefit of any electronic technology.

But the public was particularly familiar with the value and potential of videotape from television. Broadcasters would often reference the medium on air, as in the voice-over preceding programs such as *All in the Family* announcing that the show had been recorded to tape before a live studio audience. Some television production using videotape might hide the technology and its function to substitute recordings for live transmissions. The usage was no secret, however, coming up in news stories covering broadcasting such as one in *The Cedar Rapids Gazette* that warned: "So good is tape that you probably don't even realize the shows aren't live."[16] In some genres of live TV the employment of tape could also be flaunted, making the audience aware of the potential for recording technologies to manipulate the temporality of the broadcast transmission. News was one of these genres. Audiences were familiar with the repetition of recordings of significant events, such as President Eisenhower's oath of office upon his 1957 inauguration, which at the time was considered astonishing in its novelty.[17] But a more prominent usage of videotape in

television production was in sportscasts. Beginning in the mid-1960s, live sporting events were regularly employing attention-grabbing new techniques. Most prominent among these forms of electronic gimcrackery were the isolated camera (on an individual athlete), instant replay, and slow motion, often used together.[18] These were represented in popular discourses as mediated improvements over live sports, offering the television viewer an added value in comparison to the spectator present at the event.[19] The television viewer might or might not recognize that videotape makes possible the slow motion instant replay, though broadcasters called attention to the technique, explaining for instance that the broadcast replay of a touchdown in a football game didn't mean that the team had scored again. Roone Arledge, the ABC Sports producer, believed that the audience should be "aware of production" in sportscasts and appreciate, for instance, the benefit of watching a golf tournament with cameras simultaneously capturing play at many holes on the course.[20]

To those paying attention these video techniques would have offered novel forms of defamiliarization of the live television broadcast transmission. The sports pages of the later 1960s featured gee-whiz accounts of instant replay that marveled at the ability of electronic media to highlight and repeat moments of the broadcast, recognizing that the manipulation of live temporality was in some ways an improvement on the immediacy and directness of television broadcasting. The notion of liveness and simultaneity being video's essence was being challenged by

innovation-minded network producers long before academic writers identified its mythical qualities. By encouraging the television audience to appreciate videotape's importance and value, the pre-VCR television industry was already instigating a video revolution.

## Home Video Fantasies

Video was an important term in discussions in many institutional and popular sites in the later 1960s and early 1970s about prospects for the improvement of commercial media. As Thomas Streeter has shown, in this period a techno-utopian discourse of the new technology around cable television represented the future of media in terms of a blue-skies scenario of improved choice and quality and a breakdown of the hegemony of the networks and their sponsors.[21] Video was often positioned similarly to cable in this period as a liberating, culturally uplifting, and democratizing medium. It promised to be a kind of Robin Hood of media, redistributing power in communication from corporations and institutions to individuals. Home video, *Life* magazine promised in 1970, was going to "rescue the [television] medium and the viewer from the wilderness of mass programming," making for a "revolution in quality."[22] Thanks to video, media audiences would now have a newfound agency to program their own cultural experiences rather than merely choosing from among a small set of culturally degraded options offered through the limited commercial channels.

In the 1960s and early 1970s, several home video products were released to limited, if any, commercial success, but their presence sparked considerable publicity and commentary in the popular press. Ampex and Sony both brought consumer products to market in the 1960s, but they were quite expensive (Ampex's, sold through luxury department store Neiman-Marcus, had a price tag of $30,000).[23] Formats multiplied, with magnetic tape, film, and holographic disc all competing for consumers' attention and business.[24] Some, such as CBS's EVR and RCA's SelectaVision, were sold as play-only cartridges or discs (respectively), and would not permit the usage that would help sell Betamax a few years later: making recordings of television programs for time-shifted viewing.

Jack Gould was one of many popular writers who expressed excitement and hope about the video future during these years. In a September 3, 1967, column he compared home video, which had not yet found a significant market, with sound recording, a frequent reference point in explanations of video's prospective value. The headline was "Soon You'll Collect TV Reels, Like LPs," and the agenda was to position videotape as a revolutionary force for the liberation of the television audience. Like long-playing records, which Gould called "by far the most democratic" medium, videotapes would give their user the gift of a "selectivity" lacking from broadcast TV. The viewer would no longer be at the mercy of the broadcast programmer, and the TV set would replace the TV transmitter as the most valuable piece in the

ensemble of communication electronics. The discussion did not touch on the viewer's potential for recording programs off air, but rather assumed that videotapes would be sold prerecorded, like records. Classic films by the likes of W.C. Fields and Charlie Chaplin might be savored and kept in a "visual library." But as Max Dawson has shown, representatives of RCA and other firms bringing consumer VTRs to market as well as elite critics of this time did not believe that viewers would typically have reason to save recordings of television programs.[25] When the promise of video was hyped in the popular press during these years, examples of its potential offerings spoke more of its champions' tastes than of the mass market potential of a new medium. An RCA vice president quoted in a 1970 article offered these examples of ideal videocassette content: classical music, opera, ballet, moon landings, music, Hollywood films, and children's programs. Videocassettes would combine the markets for "movies, books, records, audio cassettes, adult courses, encyclopedias, business magazines and fairy tales," but not for television. The video audience had to be offered something that they weren't already getting "for free" over the airwaves. The RCA VP predicted that video recordings would be "bigger than television." [26] The new technology was being imagined as an alternative to TV. This marked a 180-degree turn from the years in which RCA's David Sarnoff touted video *as* television—in contrast to cinema's illegitimate mass culture identity—as the great new art form of the twentieth century.

In describing a future of video as a recording medium for home use, popular discourses of the late 1960s and early 1970s sometimes adopted a rhetoric of religious redemption from the enslavement of the audience to television networks and their sponsors familiar from later discourses around digital media such as TiVo.[27] In this mode of utopian fantasy, television's unfulfilled promise would finally be realized by video as a recording (not transmitting/receiving) medium. Television's viewer, long held captive by the networks, would be free to exercise choice and to be entertained or edified at his or her convenience. The issue was presented according to this rhetoric as one of empowerment: the hegemony of the networks would be stopped and the viewer newly installed as master of his or her own leisure experience. A former CBS Labs president proclaimed in 1970 that home video would be "not just another tool in our audiovisual kit; it is a new medium . . . the greatest revolution since print."[28] As George Movshon promised in a *Saturday Review* column from 1970, "The Video Revolution": "You are no longer to be merely a televisual receptacle, fit to be programmed from headquarters. Your will can be in command."[29] The consumer electronics industry tapped into this revolution talk in positioning its products in relation to the debased standard uses of the TV set. RCA's choice of the name SelectaVision for its home video product indicates the centrality of the consumer's agency in the identity of video. In discussing the logic of Sony's videotape recorders, Akio Morita explained: "I noticed how the TV networks had total control

over people's lives and I felt that people should have the option of seeing a program when they choose."[30]

The emergence of home video games at the same time as videotape was framed in many of the same terms, drawing on the same cultural tropes about TV as a problem in need of technological solutions. Home videotape decks and video games were often paired as "new TV toys," disruptive innovations changing television for the better.[31] Both videotape players and video game consoles were draining prime time audiences away from network programs in the later 1970s, which worried the broadcast industry but might have pleased a general public supposedly suffering under the broadcasters' hegemony.[32] The launch of video game systems for the home such as Magnavox Odyssey and Pong and its many ball-and-paddle imitations was routinely discussed in newspapers and magazines in terms of passivity and activity, aligning video technology with the liberated audience finally enabled to give input to the TV set. Similar to the contemporaneous theory of Hans Magnus Enzensberger, who criticized electronic mass media for their failure to be more than mere transmission from powerful institutions to the masses, popular press discourses introduced a dichotomy of one-way versus more truly communicative media permitting "talking back" to TV.[33] General reader publications such as the *New York Times Magazine* and *Time*, as well as more hobbyist-oriented publications like *Radio-Electronics* and *Mechanix Illustrated*, drew on this discourse of broadcasting as passive and video games as active,

and identified the installation of the game console as an act of transformation from passivity to activity. A key term in this discourse was *participation*, which would describe the activity of the game player in contrast to the lack of active involvement characteristic of television viewing.[34] Video games were called by many names in their earliest years, including TV games and tele-games, and their identity was very much entwined with their usage of the home television set.[35] The fact that they came to be known not as TV or tele-games but as video games suggests that they were understood not just as extensions of television but perhaps more importantly as superior alternatives to television, auguring revolution along the same lines as videotape. Video in this usage stood for two-way and participatory media, with the television audience made active, talking back to the TV set, a bold distinction from the typical use of the TV set for watching network broadcasts.

### Video Art against Television

Another connection between early games and video as a new medium can be made not in relation to home recordings but rather to artists' video. Video art emerged in the 1960s in the same cultural context as other uses of video technology and has always been understood by practitioners and critics in relation to commercial television. As Jason Wilson has argued, early video game and video art discourses were premised on many of the same conceptual terms. Both artists and video game innovators understood their work in distinction to

television broadcasting, and both practices were founded on a notion of productive spectatorship.[36] Nam June Paik's 1963 video artwork *Participation TV*, for instance, offers a use of television technology that is contrary to the general tendency of broadcast media. It involves the user in the production of a video image. The spectator's interactions with a microphone and sound frequency amplifier produce the image on a CRT set. Viewer participation and manipulation of the TV image was a possibility of video art that ordinary uses of the TV set would never permit.

Video art's emergence is often linked to the release of new videotape recording technologies such as Sony's CV-2000, a camera-recorder unit for field use that went on the market in the United States in 1965, and its more portable successor the DV-2400, released in 1967.[37] Like amateur-gauge film cameras, portable video recording technology often known as the Sony Portapak made for a more flexible and mobile mode of media production and made possible videotape usage outside of television studios and institutions. Like Super 8 movies, camcorders, and camera-equipped smartphones, portable video recording was regarded as a democratizing technology. As Ben Keen describes its impact: "for the first time a non-expert individual was able to carry around the complete means of televisual production . . . the user could be entirely independent."[38] Its champions in video art communities regarded the Portapak in opposition to television as "decentralized, anarchic, two-way, and portable."[39] Just as important as technological innovation,

however, was a cultural context in which ideas about television's profound effects circulated widely, particularly among educated elites. The growing fame of Marshall McLuhan's ideas about television was a particularly strong force, alongside the more everyday notions of TV's low-culture reputation and its domination by three commercial networks beholden to commercial sponsors eager to reach their audiences. Video art was widely publicized in the popular and alternative press, and it emerged with a reputation for being an expressive, artistic use of television technology. For instance, a famous early exhibition of video art was called "TV as a Creative Medium." A *Newsweek* story on "Television's Avant-Garde," comparing video art to off-off-Broadway theater and *cinéma vérité*, described this movement as a "pioneering corps" of innovative experimenters bent on opening up staid network programming to more "sensual and cerebral" forms of expression.[40]

McLuhan's formulation of the medium as a central concept, not just in understanding media but also modern society, influenced video artists, even if many of them had quite different concerns than McLuhan's, whether personal or political. In theorizing that each medium has distinct sensory qualities that are direct products of its materiality and technology, his writing produced an approach to thinking about television in particular that emphasized its formal qualities and their effects. As the dominant mass medium of the 1950s, 1960s, and 1970s, TV attracted much critical attention focused on appreciating its social effects and expressive potential. As practitioners in

a postwar art movement, video artists of the 1960s and after were also products of an aesthetic context in which modernist ideas about art often emphasized formal explorations of the conditions and possibilities of a medium. Bill Viola argued that avant-garde film and video artists were not concerned with making works that would be "*about* anything at all." Rather, he argued, "they actually *were* the thing."[41] Video art could reject the realist orientation of traditional art, explore the properties of its medium, and in the words of Deirdre Boyle, concern itself with the "deconstruction of the television set as material object and the re-presentation of the TV signal as material."[42] Another camp of video artists, sometimes known as "Guerrilla Television," had a different agenda of intervention into politics and social movements, but like the formalist camp this group was also thinking of its role in contrast and distinction to ordinary TV as mass medium.[43] In the essay "One-Gun Video Art," Les Levine draws a stark contrast: "Television is mass media. Video art applies only to those interested in art . . . Video art in the long run is not television. It's the medium of television being used by artists to express conceptual ideas and also to express ideas about time and space."[44] Whether formalist or not, video art was premised, in William Boddy's words, on a "revolt against the by-then hegemonic place of commercial broadcasting in defining the television apparatus."[45]

David Antin's famous essay "Video: The Distinctive Features of the Medium" is the clearest articulation of the identity of video art in relation to TV as it was understood to function in

the 1960s and 1970s. Antin's essay was published in the catalog for the 1975 Video Art exhibition at the Institute of Contemporary Art in Philadelphia, a significant moment in the history of video as an avant-garde art form bringing together the work of dozens of prominent artists and collectives. Antin, himself an artist and poet as well as a critic, drew on many of the exhibited works in his discussion of video art as a practice distinct from commercial broadcast television.

"Television," Antin argues, "haunts all exhibitions of video art."[46] His argument centers on the uses of video by artists to reveal not only the medium's properties but also the failure of commercial TV broadcasting to satisfactorily exploit them. He faults the institutional structures of broadcasting, for instance, for failing to make TV a two-way medium and to involve the audience's participation. Video art, by contrast, would make these functions possible and recuperate the medium's potential. The television audience would be liberated by video art, which would replace the mere transmission of video signals with true communication. Video art's critique of television is emblematic of a wider critique of contemporary culture.

One of Antin's most trenchant points has to do with the abandonment by the TV networks of the live aesthetic that was so central to its claims in the 1950s to cultural legitimacy. In the spirit of the golden age rhetoric, he faults the TV networks for pursuing profit ahead of cultural value by substituting a mannered, deceptive (because not live) unrealism for the live transmission of events: "The medium maintains a continual

assertion that it can and does provide an adequate representation of reality, while everyone's experience actually denies it."[47] By contrast to the close-up, fast-paced style of commercial television, Antin suggested, artists' videos had a distinctive approach to representation and time (their works being boring, and often celebrated for this quality). Unlike commercial TV, artists were trying to employ the medium in a way that would make use of—if not explore critically—its most distinctive formal features of liveness, intimacy, and immediacy, and its potential for participatory communication.

In reporting on video art exhibitions, press items would routinely draw similar contrasts between television as a mass medium and video as an art form. A *New Yorker* profile of Paik by Calvin Tomkins referred to video artists "trying to turn the cathode-ray tube into an art medium."[48] A 1975 story on Frank Gillette compared his video artworks with "the sort of thing that's geared toward selling soap." The headline was, "Videotape Replaces Canvas for Artists Who Use TV Technology in New Way."[49] Here video and TV are used interchangeably but in a way that makes clear that videotape, like a painter's canvas, is a medium of expression and that TV technology can be used either for commercial or for artistic purposes. During the 1970s many high-culture institutions such as museums and galleries exhibited video collections and initiated video departments, and the contrast between commercial broadcasting and the art world made clear the distance between video in an art exhibit and video as broadcasts. The language in a *New York Times* story

on a museum exhibit of video art speaks to the difference: "Like a number of other cultural institutions, the Whitney Museum of American Art is discovering television, or at least video." Whether video was a use of TV or a practice in opposition to it was not entirely clear, but the relationship between the two was hardly one of redundancy. In describing some of the work on display, the *Times* expanded on this contrast: "The point in each case is to create a dramatic contrast to standard video or TV, which is almost overwhelming in its openness, its determination to be impersonal and inoffensive."[50] In a 1977 story on the Intermedia Art Center begun by the New York State Council for the Arts, the headline similarly read, "TV as a Tool for the Artist," and the description of the Center's work presented its mission of making available the resources necessary for video production to artists and ordinary people.[51] Like video games, the name for this kind of media production might have included the terms *television* and *TV*. But the ultimate establishment of its identity as video art rather than TV or television art speaks to the sense of video's opposition to television as a more authentic alternative to the mass medium and as a form of critique of mass media and particularly broadcasting. It also speaks to the consolidation of TV as a term connoting commercial media rather than other uses of the CRT set and the video signal.

## The Revolution Is Here

"Video revolution" is a phrase that has endured through decades of media history. Discourses surrounding the release of Sony's

Betamax in 1975, among other home video decks, continued many of the ideas already circulating for ten years about video as a force of upheaval and transformation. The *Washington Post* in 1973 described Cartrivision and U-matic as components of a "Home Television Revolution," touting all of the convenient and empowering benefits of "cartridge television."[52] Sony's Betamax advertising tagline "Watch Whatever Whenever" delivered on the democratizing promise described years earlier of giving the viewer selectivity (fig 3.2). It also modified some of the terms of video's identity, however, by emphasizing time-shifting TV rather than playing prerecorded tapes. Sony's print ads under the header "Make Your Own TV Schedule" pictured an issue of a TV program guide covered in a large "X." A Betamax commercial demonstrating a videocassette deck along with a Sony camera encouraged the consumer: "start your own network." When recording television shows for later viewing, Dr. Joyce Brothers told the *Times* in 1977, the video recorder "actually lets you gain control."[53] While expressing disappointment over home video's failure to become the platform for arts programming earlier imagined by elite critics, some discussions also highlighted the value of home video for providing an alternative means of watching movies that, like time shifting, improved the viewer's agency. By the mid-1980s, videotape decks were in more than 25 million homes and video stores numbered in the tens of thousands. "The size of this video revolution is staggering," reported the *New York Times* film critic Vincent Canby in 1985, "even to minds numbed by Hollywood hyperbole."[54]

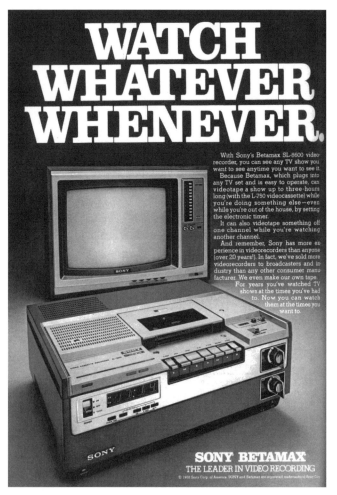

FIGURE 3.2 Sony's campaign sold the Betamax video recorder as a device for time-shifting programs taped off the air. By placing the product boldly in the foreground with the TV set in the background, Sony emphasized video's value as a technology improving on television.

At this point, video came to be caught between its positive value in relation to broadcast TV and a more ambiguous status in relation to cinema. Video allowed for the audience's selectivity in choosing what and when to watch, including movies. Their availability on tape was appealing enough in the later 1970s that some viewers spent huge sums on bootlegs of recently released films taped off the air or cable, or produced by someone connected to the entertainment business. One might spend $200 or more to own a cassette of a recent box office hit.[55] In the popular press, the advent of "TV Tape" was often represented as an innovation in cinema as well as television, as in a *New York Times* illustration in which a man seizes a videocassette in one hand and a wad of cash in the other, standing in front of a large televised image of the "Star Wars" titles, with a clutter of cables behind the set suggesting technological tinkering and exploration making possible the convergence of movies and TV (fig 3.3).

From the start of the home video boom, Hollywood studios recognized the VTR's prospects for transforming their business and their audience's expectations, and the entertainment industry greeted it as a transformational technology but also a source of uncertainty.[56] In part to stymie bootleggers, 20th Century Fox became the first studio to release its titles on videotape in 1978, pricing cassettes of movies like *M*A*S*H* and *The French Connection* for sale at $50 (and a few years later at considerably higher prices).[57] In the early 1980s, video piracy was serious competition to legitimate commerce in films on

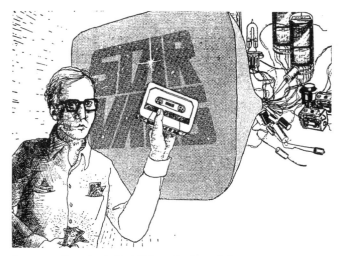

Figure 3.3 Illustration by Doris Ettlinger for the article "For Many, TV Tape Means Watching More—and Loving It," *New York Times*, August 27, 1977, using the most popular movie of the day to represent the appeals of home video.

tape, accounting for some 70 percent of prerecorded cassettes in circulation.[58] Bootlegging was a major cause of concern for Hollywood firms, which in 1976 sued Sony for selling a device enabling the audience to record films off the air, and lobbied Congress intensively in the early 1980s to impose statutory royalties on blank videocassettes and VCRs to compensate for its putative revenue losses at the hands of copyright-infringing tapers. The motivations for filing and appealing the Betamax case were undoubtedly multiple, and included a desire to protect television programs as the studios' intellectual property no less than films, as well as a sense of the imperative to assert

power in relation to Japanese electronics companies.[59] But the logic of Disney joining this legal action initiated by Universal was clearly to protect the ongoing profitability of its library of animated feature films, which it had been regularly rereleasing theatrically to appeal to successive generations of children. Disney's chairman testified at trial that the company was protecting its intellectual property from tapers by refusing to allow some of its films to be shown on cable systems such as QUBE, in Columbus, Ohio, where perhaps a dozen subscribers were known to be owners of videotape decks. He claimed that such preventive measures had cost his company $2 million.[60] The quick and broad adoption of home video by the American public made these protective efforts look silly by the mid-1980s, however, when the Supreme Court ruled that recording television broadcasts was fair use and refused to find that Sony was responsible for "contributory infringement" of copyright. By this time Hollywood had established a system of home videocassette distribution to retail outlets. Widespread piracy was averted not by judicial or regulatory intervention but by the creation of a legitimate system for the purchase or rental of movies on video.

In Hollywood's period of defensive video panic, the VCR had been likened to the Boston Strangler by the head of the studios' trade organization, the MPAA. By the middle of the 1980s, it had become a major opportunity for adding to Hollywood's revenues, and for appealing to the audience freed by videotape from relying on the TV networks for their home

entertainment. It promised to "rewrite the economics of movie making."[61] One press account of video's importance to Hollywood referred to tape as "the second great technological revolution" of film history (after sound), "which will profoundly change the art of movie making and the habits of moviegoers as well."[62]

Video meant all kinds of movies to view in the home. Especially coupled with projection television sets, another innovation of the 1970s, a videocassette deck could be one part of a home theater ensemble in the "media room," an increasingly common name for the family or recreation room. *New York Magazine*'s home furnishings photo essay on media rooms in 1976 proclaimed: "today's revolution is communications in the home." A media room in which to watch movies on a big screen would be "one big custom container for the latest in video equipment."[63] One of the owners of the media rooms represented compared his experience to living in a movie theater, which despite the novelty implied by *New York Magazine* was actually an old trope of representing televisions in the home as a combination of public and private experiences.[64]

Drawing as well on these tropes, *Newsweek*'s August 6, 1984, cover story, "The Video Revolution," balanced the two primary uses of the VCR. It told stories of movie lovers visiting video stores to rent recent Hollywood releases, as well as TV viewers time-shifting their shows. It announced that home video was soon to become "the next major mass medium," a fact sure to unsettle "almost every facet of the entertainment business."

The outcome of this shake-up was unambiguously to be a benefit to audiences: "The theme of this uprising is power to the people . . . the VCR lets viewers overturn television's tyranny." The audience welcomed the new device because it "appeal[ed] to the American love of freedom."[65]

It also apparently renewed interest in movies. Rather than siphoning from the theatrical box office, the VCR prompted new synergies between home video and theatrical exhibition. The sequel *Indiana Jones and the Temple of Doom* (1984) was helped in its theatrical run by the popularity of *Raiders of the Lost Ark* (1981), the earlier film in the series, on videocassette and vice versa. *Raiders*, at the time the all-time bestselling videocassette, was offered for sale in some cinema lobbies where its sequel was playing, and copies moved briskly.[66] *Newsweek* described the relation between theatrical release and home video as a synergy, crowing that "VCR's appear to inspire enthusiasm about movies" and noting that Hollywood had upped the number of films released from the previous year.[67]

As the VCR became a standard component in ensembles of consumer electronics, video's meanings adjusted to the medium's newfound uses. In part, these uses would mark a shift of cinemagoing, in public imagination if not reality, from a public to private activity, from going out to staying in. Video had already been marked in distinction to television, and now it was also defined in a relationship of complementarity to movies and mainstream film culture. Families staying in to watch a movie on videotape might pop popcorn

and dim the lights to re-create movie theater sensations and some of the special quality of cinemagoing in distinction to more quotidian television viewing, as I experienced as a child, while retaining the comforts of home (and the annoyances).[68] One ad for an RCA videodisc player, whose tagline was, "Bring the Magic Home," pictured a man holding a box of popcorn sitting in the glow of his TV screen, surrounded by attractive women lured to his side by movies on video. This representation reproduced the social function of cinema as a place for heterosexual courtship, but relocated to the space of the home (fig. 3.4).

The television set was supposedly improved by video's revolutionary transformation into a technology to rival and substitute for the cinema, though at the same time cinema was brought down to the size of the home and the television set. The contradictory significance of the VCR suggesting a merging of public and private, big and small, was conveyed in *Newsweek*'s "Video Revolution" cover art. An illustration represents a VCR on a monumental scale, the size of a neighborhood movie house, with spectators queued up around it as if to pass into the tape deck–cum-theater (fig 3.5). The video revolution of this representation redefined categories of leisure experience by revising prevailing conceptions of television and cinema as mass media. In this way the medium of video negotiated between these audiovisual siblings and reinforced their mutual distinction even as it also introduced a new ambiguity to their relationship.

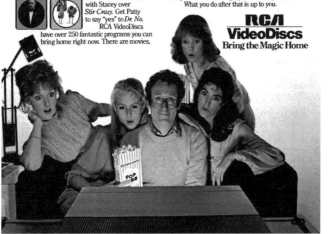

FIGURE 3.4 An advertisement for RCA VideoDiscs in a 1982 issue of *Playboy* represents video bringing the culture of moviegoing into the home, while also reinforcing associations between new technology and masculinity.

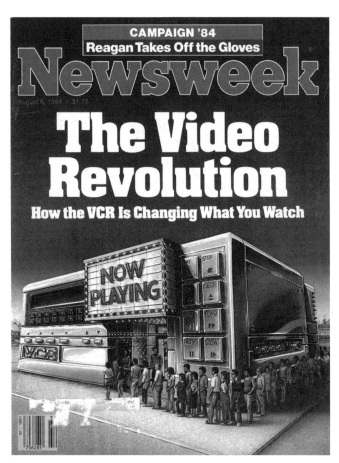

FIGURE 3.5 *Newsweek*'s cover on August 6, 1984, announced *The Video Revolution* picturing a VCR as a movie theater.

## Video as a Masculinized Medium

Hollywood got richer from cassettes and VCRs, but home video also quickly became a major market for another kind of movies. Pornographic feature films, which had enjoyed a period of unprecedented popularity and theatrical success earlier in the 1970s as more than 700 theaters screened hard-core titles, found a huge commercial opportunity in prerecorded videocassettes.[69] This tapped into an existing market but also expanded the interest in explicit sexual representations to include consumers unwilling to view such films in public at an X-rated movie theater. Adult films were the "first big genre for prerecorded cassettes," writes Frederick Wasser, making up half of all prerecorded videotape sales through the end of the 1970s.[70] This led to an expansion of the porn industry and its abandonment of 35mm film for video. In the context of the 1970s, however, the shift was not of production from one medium to another but rather of consumption from public to private places. A colorful 1980 *Playboy* cartoon captures the tensions in the uses and meanings of prerecorded videocassettes: a man is seated at a desk viewing a television image while operating a videotape deck. By his side is a pipe and an issue of "HI TECH" magazine. The image on the TV screen is of two nude women, one atop the other in a sexual pose. Above the man stands his wife, lips pursed and eyes on the set. The caption reads, "You didn't think I bought this baby to tape 'Masterpiece Theater,' did you?"

As not only the pornographic content but also the "HI TECH" magazine in the cartoon indicates, interest in the VCR as a new technology was a masculinized form of early adopter culture alongside other forms of hi-tech gadgets. With video decks for consumers, video sprouted new associations in relation not to movies and television but to other forms of home electronics technology aimed at mainly male hobbyists and connoisseurs. This placed video alongside photography, audio tape recording, hi-fi stereo equipment, home computers, home movies, and similar types of tech-fetish hobbyist and collector pursuits.[71] The gendered character of society's adoption of new technologies typically invests them with forms of patriarchal power.[72] While the VCR was later feminized by some of its uses in the home, in its early years it was marketed as advanced technology for male consumers. In Ann Gray's study conducted in the 1980s, male dominance of VCR programming and controls (though not of watching) was evidence of a gendered division of household labor, rendering female technical competence invisible.[73] As a gadget for men's active use, video would be a departure from the feminized, passive medium of TV.

An example of this gendered video culture is *The Videophile*, a newsletter "published monthly at the whim of Jim Lowe" of Tallahassee, according to issue #3 of November 1976, mailed to subscribers to facilitate tape trading and to keep them informed of news about video technology. Lowe was particularly excited by the newfound ability to archive television programs and advertisements (which he defended including in recordings),

though he noted that most readers were more interested in collecting movies. In a list of names of videophiles and their interests in this issue, all were men. *The Videophile* print run in these days was only 100 copies, but these concerns indicate a social positioning of video within a context of masculine collecting and hobbyism.[74] When video cameras emerged significantly onto the consumer market, more professional publications would similarly integrate these new technologies into the culture of photography and stereo enthusiasts. The similarity of *videophile* with the terms *cinephile* and *audiophile* positions interest in the new technology in relation to cultures of connoisseurship and discernment with overtones of gender and class identity. ABC Publishing began to print the magazine *Video Today* in 1980, contained within two of its other titles and written by their staff: *Modern Photography* and *High Fidelity*.[75] Jack Gould predicted in the 1960s that video would be more like LPs than TV. In the emergence of *Video Today* and many similar forms of video culture in the 1970s and 1980s, video's identity extended its move away from mass culture and entertainment by association with masculine forms of artistic and technological leisure pursuit.

Later in the 1980s and 1990s, *The Perfect Vision*, a quarterly that billed itself "The High End Video Journal," was aimed at what Barbara Klinger would later call home theater "new media aristocrats," male connoisseurs of the latest audiovisual technology and the video equivalents of affluent hi-fi and photography hobbyists.[76] The most sanctioned use in

the discourses of masculine tech enthusiasts for video was to watch great movies in the home, as many a *Perfect Vision* cover would represent. One issue's cover pays homage to *The Wizard of Oz*, with the characters seemingly stepping off the filmstrip of the past into the video yellow brick road of a technologically advanced future. Another cover plays with *Singin' in the Rain*, as the movie's hero Don Lockwood swings from a lamppost in the film's signature number, a satellite dish taking the place of his umbrella (fig. 3.6). Through the application of technology, such imagery suggests, the male video hobbyist can achieve an upgraded experience of cinema. This visual rhetoric further distanced video, as a technology of active and sophisticated connoisseurship, from the feminized domestic medium of broadcast TV.

## Cinephile Anxieties

For the cinephile connoisseur in particular, video would be a mixed blessing at best. In addressing the value of video as a means of viewing theatrically distributed feature films, movie lovers attentive to the materiality of media, such as readers of *The Perfect Vision*, would necessarily consider the quality and character of video as technology. They understood this in relation to the 35mm standard of first-run theatrical presentation and weighed the benefits of expanded access ("Watch Whatever Whenever") against the costs of video's difference from film, most often regarded as a deficiency or poverty of the image and, less often, the soundtrack. Watching movies on a television set

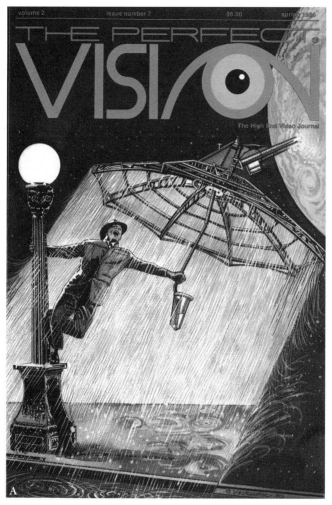

FIGURE 3.6 The (A) Spring 1990 and (B) Spring 1991 cover artwork by Gary Viskupic for *The Perfect Vision* conveys the potential of home video technology to improve on the experience of cinema and bring film classics to life in the home.

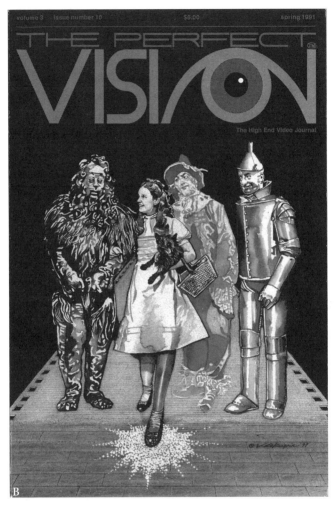

FIGURE 3.6 Continued.

might still be considerably higher in cultural status than watching broadcast TV, but videotape versions of movies were still wanting in authenticity and legitimacy compared with movies exhibited theatrically, particularly in 35mm. In cinephile and technophile discourses, video was often regarded as a medium of reproduction rather than a legitimate and authentic alternative format for viewing a movie. In some ways this positioned video as fraudulent insofar as it might appear to be a fair substitute for film. Cinephiles might regard movies on video as a secondary option after seeing the original artworks, just as photographic reproductions of paintings would be regarded in the art world in distinction to canvases hanging on gallery walls. Such discourses, however, would still position videotape movies above television broadcasts, despite the technological interchangeability and ambiguity of these media.

In its status as an alternative medium for exhibition of feature films, video laid bare the discursive distance and opposition between cinema and television, media forms that would seem to have so much in common aesthetically and technologically. After all, so much of television's content since the later 1950s has been filmed, and the techniques of film and video production are substantially the same. Efforts to distinguish video from cinema, particularly in the overlapping cinephile and academic press, would counterbalance the rhetoric of revolution, reimagining video not as the redemption of the TV audience but as the temptation, corruption, and possibly the ultimate decline of cinema and its culture.

These ideas had been brewing already through decades of televised cinema. In the network era, movies were among the most popular programs on television, airing frequently on both networks and local stations, and often in prime time to high ratings as well as late at night. But Pauline Kael insisted in her nostalgic 1967 *New Yorker* essay "Movies on Television" that one cannot judge a film after viewing it on TV, and claimed that spectators remember less of the movies they watch at home.[77] The experience of the film as a visual work and of its rhythm and pacing are too badly affected, and the "housebound, inactive, solitary" nature of home viewing is too different from being in the theater. Television, a mass medium always reduced to selling, is, according to her account, incapable of beauty. Television cannot transmit the aesthetic qualities of a motion picture made for the cinema (which unlike TV is capable of art), and certainly cannot convey the excitement of cinematic set pieces like cattle drives and chases. Kael was contemptuous even of the wide availability of so many old films on television, making it harder, in her argument, to tell the good films from the bad and to see them as they were originally regarded by audiences of the past. While clearly confessing to taking pleasure in revisiting old movies on TV, Kael was also drawing a boundary line separating one kind of experience of movies from another in terms of value, quality, and cultural legitimacy. Cinephile culture carried many of her distinctions and concerns forward when videotape further expanded the availability of movies for TV viewing.

The expansion of cable television in the 1970s and 1980s meant more movies on TV, as both premium and basic channels filled their schedule grids with theatrically released films. This allowed for many classic movies to be more widely seen and collectively remembered, but it also meant the editing and interruption of movies for standards and commercials and the reduction of the picture to fit the resolution, size, and shape of NTSC displays. To film lovers and critics, movies on television also functioned as a kind of translation, producing different effects, often to the detriment of cinema as a medium and art. The practices, common in the home video age, of colorizing, cropping (panning and scanning), and letterboxing films transferred to video made apparent the transformation involved in migrating media.[78] The computerized addition of color to old black-and-white movies for release on videocassette and airing on TV was a particularly galvanizing issue in the later 1980s for defenders of film against video's threat. Critics of this practice were typically disgusted by what they regarded as vandalizing cultural heritage for commercial gain and pandering to a mass audience's taste. Many saw this threat as television's unwelcome incursion against cinema.[79]

For Hollywood's broad audience, home video might not have posed a radical challenge to the identity of movies as a cultural form. Video essentially expanded an engrained practice of viewing movies in the home. For the still-young academic field of film studies, however, and for readers of publications such as *Film Comment*, *Film Quarterly*, and *Sight & Sound*, the

medium of video was often regarded as a cause for alarm even if it was also sometimes welcomed as an opportunity for broader access to movies. Richard T. Jameson described in a 1991 *Film Comment* essay how "this bastard brother of television seemed to threaten the integrity—maybe even the existence—of films *on film*," though he also offered his appreciation of the medium and its inevitable presence in film culture.[80] Charles Tashiro, who had worked at the videodisc distributor Criterion, charitably referred in a *Film Quarterly* essay to the transfer of texts from film to video as a process of translation, describing a range of compensations and corrections made during this work. "Videocassettes and discs are like large shards," he wrote, "hints of the original."

As with many commentators, Tashiro took care to point out technical differences between the two media, particularly in terms of color, resolution, and sound. And like some others, Tashiro also made a balanced case in favor of video in instances when the alternative might be a poor quality print, perhaps a 16mm transfer, projected badly or under unfavorable conditions.[81] Many repertory cinemas, film courses, and campus film societies of the 1970s, 1980s, and 1990s exhibited films using 16mm prints of questionable quality, so good video versions might have been preferable in many instances. Video versions were not all the same, as the regular "Life with Video" column in *Film Comment* would point out in the early 1990s. Technical aspects of film-to-video transfer and aspect ratios varied from one version or title to another. A movie taped off the air might

differ in quality from prerecorded cassettes, but television might also air films not available for sale or rental. Laserdisc was preferable to cassette, and the prospect of high-definition TV would be welcome as another improvement of the image.[82]

In such writing, cinephile authors established value-laden terms of legitimacy for serious, intellectual film culture. Video technology such as tapes and discs would be integrated into this culture without compromising the essential cinematic experience as theatrical 35mm film projection. Film might not always have every advantage, but video could not be seen as a legitimate substitute, never mind as equal to film, all things considered. By comparison with 35mm, the authentic and original instance of a movie, as well as by association with the medium of television, videotape or videodisc versions of movies were regarded as compromised. While technical issues were most often given to support this rhetoric, ultimately more ineffable qualities having less to do with technology than with cultural distinction also frequently carried the argument through. Even a future scenario of improved television resolution would fail to be an adequate solution to the problem of films on video due to the limitations inherent in television's identity and cultural status as an "alien medium."[83] Frank Thompson elaborated this case in eloquent, emotional terms in the pages of *Film Comment* in 1992:

> Unfortunately, "something like" [the original form of film] is as good as laser [disc] can get. Even the long-promised Video

Messiah, HDTV, isn't going to give us back everything we've lost in the film/video trade. Films need size, darkness, the undivided attention of the audience. They need to be able to create an entire world for us to live in for a while. Television, even at the highest of hi-tech, is simply not able to deliver this experience on so many levels . . .

By embracing video to the exclusion of real film exhibition, we're consciously and voluntarily surrendering many of the things that make film unique and wonderful, in exchange for convenience. Laserdiscs are swell, but they're just reminders of the real thing. You can gaze at your postcard of the Grand Canyon all day long, but it won't give you that breathless thrill you get when you're standing right there on the rim.[84]

In this mode of cinephile anxiety, video is a sham, a television-based means striving to replace cinema rather than an alternative to TV or a liberating new use for its technology. A rhetoric of authenticity (video can be "something like" but never the "real thing") positions the new technology as an object to be feared and mistrusted. The clearest notes sounded are of caution and loss. Film culture hangs in the balance, liable to be discarded in favor of the ease of a superficially appealing but less vital and ultimately inadequate simulation of cinema.

Some academic writers would also sound this alarm but in more fearful and defensive tones. Video presented an opportunity to broaden offerings in film studies at a time of the field's expansion. It was a cheaper alternative and often rivaled 16mm prints in visual and sound quality. In terms of convenience and accessibility, video had strong advantages, and in the later 1980s

came into wider use in university classrooms. As ever, university budgets were tight and administrators on many campuses viewed video as an acceptable or desirable substitute for film print rentals, which were rising in price. Film scholars and teachers were often reluctant to abandon film, however, and many resisted the pressure to replace films with tapes and discs.

The Society for Cinema Studies (SCS) convened a Task Force on Film Integrity to consider the use of video in the classroom, and its report appeared in a 1991 issue of *Cinema Journal*. The Task Force's stance on the issue was unambiguous and severe: "No film can be adequately represented by its video version."[85] After comparing the 35mm and 16mm film and NTSC video images in terms of resolution, the report concluded: "Film images are . . . sharper, more detailed, possess a higher resolution, and carry more information than do video images." The report also compared the images in terms of contrast, aspect ratio, and color reproduction, arguing that video is an "inferior medium."[86]

Consequently, the Task Force warned university administrators that classroom use of video posed a threat to the integrity and rigor of film studies as a discipline. It cautioned that video would make a poor archival medium, as tapes would not endure as long as films; it would be shortsighted to invest in video libraries. The authors not only insisted that film must continue to be taught on film, but also asserted that "[m]ost of the key aesthetic components of the cinema do not survive the transfer of film to video" and referred to video not only as

a "substitute" and "inferior facsimile" but even as "a form of counterfeiting."[87] At stake in this fight was not only the preservation of one medium or another, but of the identity of scholars of the medium under threat and the collective scholarly project they were undertaking.

Reporting in the pages of *Film Quarterly* from an annual meeting of SCS and the University Film and Video Association in 1988, Bruce Kawin made similar claims even more forcefully. Among the themes considered at that conference, according to Kawin, were distinctions between film and video and video and television. In the face of administrative pressures and shrinking budgets, film scholars had taken to video as a substitute for film screenings, and in Kawin's reporting, video had won the debate over whether to teach film history and aesthetics using film prints or videotapes and discs. He addressed this development as a crisis, claiming to have "heard the sound of Film Studies desiring the spectacle of its own destruction." One unnamed scholar at the conference foresaw a future in which high-definition video would erase the distinction between electronic and photochemical media, and television and cinema would be part of a wider field of moving-image media studies. Kawin treated this prospect as an existential threat and described the potential effect of video's dominance in film courses in quasi-Biblical terms: "I think I heard people selling wallpaper for the house of bondage."[88]

Like the cinephile press and the Task Force on Film Integrity, Kawin ultimately saw this crisis resolving on the very

definition of cinema in terms of its essential qualities, a definition expressed in terms of the materiality of the film image and apparatus. As in other examples of such reasoning, this argument ultimately could be made most strongly in impressionistic, evocative language distinguishing film from its rivals rather than through convincing logical and empirical claims. Kawin defended the appreciation of "every aspect of a movie that is just not there and not happening when the 'same text' is played back through the TV set." These aspects were described as: "the aura of the real thing, the richness of the dyes, the dark, the silver, the quality of the light that flickers from behind you. . . ." As with other writing defending film against movies on video, this brief for the older medium relied on a rhetoric of authenticity that made the case for cinema's essence most crucially as a negation of television. In this argument, video was a failed effort to make cinema more accessible and accommodating, and a threat to the future of film qua film. If cinema has maintained an identity distinct from TV and video in the years since these defensive discourses were articulated, it has been in the face of video's continuing—and intensifying—embrace of all audiovisual media.

## Camcorders, Democracy, Authenticity

In the 1950s, video was represented as a positive alternative to cinema. In the 1980s and 1990s, cinema was represented as a positive alternative to video. The material qualities of the two media had not changed substantially in the interim, but film's

cultural status had improved to the point that it was frequently taught alongside literature in college classes, while television's status had quickly degraded following its initial golden age. The fortunes of these two media in terms of cultural status make a bold reverse image in the 1960s, even as Hollywood studios moved into producing filmed television programs in their soundstages and back lots in significant quantity, intensifying convergence of movies and TV industrially. Serious film culture blossomed in the 1960s, as festivals, art house theaters, and highbrow publications consecrated classics and celebrated directors as artists.[89] It was a cultural moment of widespread cinephilia, with many prominent intellectuals and critics looking at cinema as a medium of modern art. It cannot be a coincidence that film was culturally legitimated at the very moment that its status as dominant mass medium was ceded to TV. Television was its bad-object other, artless and hypercommercial, satisfying the base interests of its mass audience.

At the same time that cinema was seen to be threatened by videotape, however, video was undergoing another of its revolutions, the one associated with camcorders and amateur or home video. If cinema, and Hollywood in particular, have had an abiding identity as a dream factory and source of illusions and fantasies, television and video have maintained their reputation for access to reality and instantaneity, their ideological positioning as unmediated media. Authenticity has historically cut both ways with video: if video has failed to be authentic as a medium of film exhibition, it has also succeeded

as a medium of authentic representation of the real world, and of civic engagement and democratic participation. It seems particularly arbitrary that a medium so much criticized for its visual poverty and insufficiency relative to film would also be seen to have the advantage when it comes to representing the real. But through a cluster of cultural and historical processes, video has often been invested in popular imagination with this quality of access to actuality owing to its capacities to record and document everyday life and events of political and historical importance, and to the increasing ubiquity of video cameras in modern life for surveillance and amateur recording. In previously recorded television productions such as situation comedies, for instance, video has sometimes been the preferred format over film for its live look and its associations with broadcasting rather than cinema. One famous instance of this preference was *All in the Family*, a comedy noted for its social relevance recorded on tape rather than film. As video became a cheaper and easier alternative to film for many uses outside of the entertainment industries, electronic rather than photochemical media came to be associated more with the image of the real.

One moment in which this association was reasserted occurred on television in the fall of 1980. The FBI's Abscam sting operation of the late 1970s and early 1980s had caught state and federal legislators accepting bribes from agents including one pretending to be a wealthy Middle Eastern immigrant seeking asylum in the United States. Secretly videotaped

surveillance footage of acts of political corruption in a hotel room, where elected officials met the agents, proved to be sensational and irrefutable evidence in court, leading toward convictions. Soon after the sting was first made public, these events were parodied in a *Saturday Night Live* sketch spoofing *The Beverly Hillbillies*, "The Bel-Airabs," reinforcing the linkage between video recording and the real, and videotape's familiarity as a medium of capturing and documenting actuality.[90] After a well-publicized Supreme Court decision allowing it, the evidentiary videotape was broadcast on television evening news programs on October 14, 1980, an event marked in popular criticism as a historic occasion for both television and video. The *Washington Post* TV critic Tom Shales noted the "video *vérité*" look of the images, and essentially predicted what would later be called reality TV, as surveillance and other forms of taped footage were likely to find their way onto the airwaves in the near future as both news and entertainment. Shales imagined that this would "change the way we look at the tube—and the way it looks at us."[91] Video cameras had been available to consumers for more than a decade by the time of the Abscam case, but were not widely adopted in comparison to video recorders until the 1980s.

When video camcorders were released to the American market in the mid-1980s, they offered consumers a more compact and portable alternative to earlier video cameras, which required separate camera, microphone, and shoulder-strap tape units. Camcorders were marketed as an "all-in-one"

technology, tapping into the rhetoric of democratization of media that has accompanied many new devices promoted as easier to use than their predecessors.[92] While they were heavy and bulky compared to succeeding models, weighing as much as eight pounds, early camcorders made ordinary people rather than just tech enthusiasts and early adopters likely to shoot video and to produce audiovisual media.

Camcorders also quickly became a way for amateur media products to find their way into professional broadcasts and cable news programs, much as Shales predicted. Some of this video was in the mode of home movies, but the availability of less expensive and easy-to-use new video gear expanded the practice of amateur media production of many varieties. Amateur videos were made more famous by the ABC network's *America's Funniest Home Videos* (*AFHV*), a long-running series based on user-submitted clips, which began as a 1989 special and continued to air more than two decades hence into the 2010s. *AFHV* and other audience-submission programs such as *I Witness Video* motivated and encouraged viewers to make and send in a certain kind of videotape, and in the later 1980s and 1990s, shooting camcorder footage was seen as a way for ordinary people to "get on TV" and participate in mass media discourse that had hitherto been closed off to them, claiming a place in the national media conversation.[93] The ubiquity of camcorders led *Newsweek* to declare, in a moment of moral panic, that "amateur videographers lurk everywhere" eager to capture comical, lurid, revealing, or sensational events on

camera.[94] According to a more hopeful *Columbia Journalism Review* essay published in 1991, footage of events such as earthquakes and tornadoes taken by ordinary citizens shooting with camcorders "add a democratic dimension to television journalism worldwide."[95] Democratization of media in this sense meant not only democratization of the means of production but also of access to the airwaves, to network and cable news and public affairs programming and reality TV like *I Witness Video* and *AFHV*, though always on the terms of the commercial industry and its regulators.[96]

Camcorder video gained significant notice before long for practices linked to another conception of democratization. Some newsworthy camcorder footage in the later 1980s and 1990s represented issues of civic and political significance, promoting democratic governance and values around the world. The most famous amateur video of this time in the United States was George Holliday's recording of the beating of a black citizen, Rodney King, by Los Angeles Police Department officers. This footage aired many times on television after Holliday submitted it to his local station, and was taken for indisputable evidence of police brutality. The King affair was significant not only in the history of urban race relations and unequal criminal justice, but also for the centrality of amateur media to its narrative unfolding. As a Ted Koppel ABC News special *Revolution in a Box* reported in 1989, circulation of amateur video (along with satellite technology and other innovations in communication) was also opening up state-controlled media

systems in many other parts of the globe, particularly in the crumbling Soviet bloc and in politically tense regions of the developing world. Koppel described the shift both at home and abroad in dramatic terms: "Television has fallen into the hands of the people . . . A form of television democracy is sweeping the world, and like other forms of democracy that have preceded it, its consequences are likely to be beyond our imagination." The camcorder revolution was in a sense more literally revolutionary than other video revolutions, as its impact was seen in terms not only of changing social practices but also in terms of political effects, opening up communications to a greater range of voices and images and thereby diminishing state and corporate power. When a public uprising in Los Angeles followed an almost all-white jury's acquittal in 1992 of the police officers TV viewers had witnessed beating Rodney King, the video technology that enabled this witnessing was credited with training attention on a serious social problem. This problem, according to contemporary discourse, would not have been recognized in the same way absent the ability of individual citizens to document everyday reality truthfully and accurately. As a consumer electronics trade paper described, this event marked the historical moment when "the 'camcorder revolution' shook the nation by exposing police abuse and its racial undercurrents."[97]

Whether in the slapstick backyard comedy of *AFHV*, the gritty violence and confrontation of *Cops* and the Rodney King beating, or the alternative media of political movements the world over struggling for democratic freedoms, the form of

video associated with camcorders and citizen media production was closely tied to ideas about video's capabilities to capture and document reality in ways that existing media systems had not accomplished. In this construction of video, the enduring identity of television as a medium of directness, immediacy, and transparency was married with the tradition of documentary cinema's rhetoric of truthful capture of actuality in all of its detail and ambiguity, a tradition stretching back to the earliest days of moving pictures and before that to photography. A press release for *I Witness Video*, the NBC series that ran from 1992–1994 depicting crimes and disasters caught on amateur videotape, boasted that "the video boom lets Americans see each other as never before."[98] Amateur video was recognized as a way of revealing society to itself, for making visible previously hidden or inaccessible human experiences. Camcorder images, Jon Dovey argues, became "*the* privileged form of TV 'truth telling,' signifying authenticity and an indexical reproduction of the real world."[99] Video's authenticity and realism benefited from its technical limitations in achieving this sense of truthful directness, and from the handheld shooting style typical of amateur videography. A TV news producer in Tulsa, Oklahoma, told *Columbia Journalism Review* that footage shot by amateurs included in newscasts has "an unpolished quality that tends to make it seem more real." Moreover, she argued, subjects who might "sanitize" their actions in the presence of a professional news crew are less aware they are being recorded by ordinary citizens.[100]

The "more real" quality of amateur camcorder footage soon became integrated into fictional media as well in the form of diegetic video, what the TV Tropes website calls the "fake video camera view." One type is the camcorder image presented in films and television series as the production of characters in the narrative and coded as intimate and personal, probing the surfaces and depths of everyday reality. In movies such as *Reality Bites* and *sex, lies, and videotape* and television shows such as *My So-Called Life*, the switch from the usual film aesthetic to the view from a character's camcorder is presented as an index of realistic narration. The imagery in such sequences is often presented from the operator's POV, marked as video by framing lines, the REC or battery life indicators, and sometimes by a distinct video quality such as scan lines or differences in color and light. The device of characters shooting video in films and TV is not only evidence of society's embrace of amateur camcorder video but also of the status of video in the years of the camcorder revolution as a medium for the representation of the everyday lives of ordinary people. Another type of diegetic video is the surveillance camera footage familiar from crime dramas such as *CSI*. Like the diegetic camcorder device, the use of surveillance video as evidence in police work is a product of a society of ubiquitous video recording. The two devices are also similar in their use of video as an indexical medium. In its function as visual evidence for use in the prosecution of crimes, video in fictional representations extends the same meanings offered by the King case and the examples given in

*Revolution in a Box*. In popular imagination, video recording truthfully captures the image of reality and provides a faithful and useful record, and this valuation of "raw" video is in contrast to the less "real" (fictional, idealized, fantastical) cultural value of commercial narrative media, particularly film and television.

From the 1950s to the 1990s, video developed in multiple directions, performing various functions and producing a number of perceived effects and consequences. Its identity was contingent on its uses and affordances, and on widely circulating ideas about their social or aesthetic significance. Such notions depended most often on an understanding of video's relation to other popular media. Where video was valued, it was in contrast to prevailing conceptions of television. Where it was denigrated, this was a product of its enduring association with the small screen and its identification with commercial broadcasting, the epitome in these years of mass media. Video's identity was inconsistent as some uses and ideals of videotape recording and playback technology clashed with others, and its identity as a medium depended on how its uses and affordances were perceived and evaluated. Videotape was a technology characterized by interpretive flexibility, as different social groups constructed it according to their needs and interests.[101] The medium's status was negotiated in relation to this flexibility.

Most of all, what the cultural status and identity of video in these years reveals are anxieties surrounding television's status

as the most powerful mass medium, a formidable hegemonic institution of the later twentieth century. As the next chapter proceeds to the twenty-first century, TV retains this force, but new configurations of technology and social relations will complicate the distinctions of value and legitimacy that gave shape to phase two.

# 4
# VIDEO AS THE MOVING IMAGE

In the digital age, video has come to include practically any kind of object combining motion pictures and sound. Movies and television persist as ways of describing media and our experience of it: going to the movies, watching TV. As categories of texts and experiences they show no sign of going away. New formats like web television and digital cinema seek legitimacy by taking the names of established forms. But film and video's materiality and specificity as media have lessened in significance in an era of digital convergence and the shift from filming to shooting HD video for many kinds of media. These changes can be understood by looking not only at technologies but also industries, texts, and social practices. New digital media remediate analog media, including film and video. To understand them by their names, Netflix and YouTube are efforts at the remediation of cinema and television,

respectively. But as they are experienced on cinema and TV screens, on computer displays and mobile devices, media of the moving image are more and more simply video. Netflix, YouTube, and video on demand (VOD) are delivery systems for movies and television shows, among other things. Video now names a larger category than it did in phases one and two.

In the twenty-first century, digital has triumphed to the point that audiences for media in the United States may seldom experience analog moving images. Since 2009, television transmission in the United States has been digital, and cathode ray tube television sets have been rapidly replaced by high-definition, flat-panel LED, LCD, or plasma displays with pixels rather than picture tubes. In the 2010s, it is not uncommon to see CRT television sets along the side of the road, left out with the trash, treated as abject old media refuse. Goodwill stores sell CRT sets for 99 cents, less than their price for a hardcover book.[1] Manufacture of CRT television sets had largely stopped by the later 2000s. VCRs and videocassettes have given way to DVDs, DVRs, VOD, streaming video, and downloads of video files, all promoted as improvements over earlier technologies in terms either of quality or convenience. *Variety* ran an obituary for the VHS cassette in 2006.[2] Film exhibition has been transitioning to digital projection, and the screening of 35mm prints in commercial cinemas will likely not endure past 2015.[3] Web video in its various forms—amateur, professional, and in between—has become a powerful force culturally and economically.

Means of access to movies and television shows have been converging as cable television and online services deliver many kinds of content to consumers. Web users searching for torrent files to use in accessing movies and TV shows are ultimately downloading and uploading the same kind of AVI files regardless of the content's original formats of broadcast or exhibition. On an Apple iOS device like an iPad, both movies and TV shows are viewed using an application called Videos, and the interface is the same no matter the content. Using cable and satellite provider menus and guides, TV viewers select many forms of content from VOD search and menu windows including TV episodes and feature films. Using Hulu, Netflix, YouTube, Amazon, iTunes, and the many other digital services, the media audience selects from options that include movies and TV seasons or episodes, making them experientially continuous and equivalent.

Our experience now makes hard distinctions between different media less logical. Film and television can no longer be understood so easily in terms of space (theater/home) or materiality (film/video) or aesthetics (big screen, cinematic/small screen, televisual). Both are experienced in various spaces and on screens of various dimensions. Industrially, media are not very well split into film and television companies. Television is a more profitable side of the business for the Hollywood studios than cinema, and filmed entertainment accounts for production and distribution of both media. Since the triumph of the VCR as a consumer technology, Hollywood has earned

most of its income from what the studios call home entertainment—as of the early 2000s, films and television programs distributed on DVD and other forms of digital video such as VOD and downloads. These nontheatrical sources of revenue, by all accounts, provide the media conglomerates with several times more income than the multiplexes.[4] As Caetlin Benson-Allott puts it in her study of video spectatorship, "movies are now primarily videos for both their makers and their viewers."[5] Furthermore, increasingly the profit centers of the media conglomerates are cable television providers and channels, which deliver a wide variety of "filmed" entertainment. When Comcast completed its acquisition of a majority share of NBC Universal in 2011, it signaled the rise of the cable and Internet provider to the top spot in the industry hierarchy in terms of revenue and corporate power, a position built on its ability to exploit the most lucrative forms of video content. Notably, its most valuable assets would not be its film and TV production studio or television network but its cable systems and channels providing video of many kinds to its customers, and the Internet connections it provides along with cable service, which also are channels for video. According to 2012 figures, Netflix and BitTorrent together accounted for around 40 percent of traffic over wireline broadband networks.[6]

Before the digital age, cinema and television had more distinct and opposed identities. In the 1960s, Marshall McLuhan called one cool and the other hot. Jane Feuer wrote in 1983 that "the differences between television and . . . cinema, are too

great not to see television as a qualitatively different medium."[7] But in 2000, Anne Friedberg wrote that "the differences between the media of movies, television, and computers are rapidly diminishing."[8] In the time between these statements, many changes had occurred on all of the levels at which we can approach media: texts, industries, audiences, and technologies. Digital platforms and the practices associated with them were changing the relationality of movies and TV in particular as distinct and opposed media. In recent years one hears many more statements like Friedberg's than Feuer's. Digital video is the format for movies, television shows, web videos, and whatever audiovisual texts fail to match these categories. It is, more and more, the moving image.

## Video Convergence and Interactive Multimedia

For decades, media experts and prognosticators foresaw a future of television sets connected to computer networks, as the home screen would deliver content such as news, sports results, and stock market reports as ordered up by the viewer, who might participate more in civic life electronically and vote using CATV lines. Two-way transmission was supposed to be one of the blessings soon to come along with cable TV, according to a report published by the Rand Corporation in 1971.[9] The networked television could be used for home shopping and banking and to send and receive electronic mail, but in hopeful prognostications it was most often pictured as a source

of useful information and edifying entertainment. *Life* foresaw a time not too far off from 1970 when "the computer, the cable TV data bank and the [video] cassette reach their full conjunction."[10] The same 1970 *Saturday Review* column on the "The Video Revolution" singing the virtues of home video also predicted that the future home TV set would have "total access to such of the world's wisdom and pleasure as eyes and ears may receive," including "a storehouse of *all* the published materials in existence."[11] This would augur the end of print newspapers and magazines, which *Life* imagined would appear instead on television screens.

Computer networks did deliver data in the form of text and sometimes image to the home in the late 1970s and early 1980s using telephone and cable lines and home TV sets in France, Canada, the United States, the United Kingdom, and several other countries. (Sometimes they also used computer monitors or special display sets.) Many of the American companies involved in testing and offering this service were in the cable TV industry, including Warner-Amex, Cox, and Times Mirror. One of the names for this interactive technology of "pushbutton fantasies," videotex, speaks to the identity of video as an alternative use of a CRT display for more interactive or productive or socially beneficial purposes than TV, but also to the importance of the CRT display as a commonplace object bridging experiences of television and computers.[12] An illustration of videotex on the cover of a 1983 issue of the personal computer magazine *Byte* represents an idealized future convergence of

technologies that resemble already familiar artifacts and experiences. A modified model 500 Bell System telephone with a screen on its face produces a magical shaft of light, while television rabbit ears protrude from behind and a QWERTY keyboard peripheral looks as much like a calculator as a typewriter. The videotex display offers a menu of options: news, banking, shopping, electronic mail, games, and computing—but no watching television (fig. 4.1).

In the 1990s, the Googlesque dream of offering all of the world's published materials to users in their homes seemingly began to be realized in earnest. The Internet, a more open network than the services to be offered through videotex, expanded from institutional use in government and higher education and became available to the consumer market just as it also gave birth to the World Wide Web. The Internet promised to integrate television—or at least video—into its virtually infinite potential range of offerings, though not until the bandwidth became robust enough to allow for transmission of data-heavy moving-image files. At the same time, the idea of connecting the television set to the Internet promised to further open up TV to a new range of content and to the interactivity of digital media. Desktop video editing, another of video's revolutions, promised to make every enthusiastic camcorder user with a Mac computer into a sophisticated media producer with the means to share polished audiovisual content online. Whether digital video was standard or high definition, the differences between digital and its analog predecessor in terms of image

FIGURE 4.1 *Byte* magazine, July 1983; cover artwork by Robert Tinney depicts a future of convergence integrating many familiar objects: CRT display, telephone, television antenna, and calculator.

quality promised to overcome some of the perceived deficiencies of videotape, widely regarded as an aesthetically degraded and flawed format.[13]

The cultural implications of televisions being networked and of networks conveying moving pictures were in some ways consistent with the history of rhetoric about video. The promise of computerized video had long been seen as democratizing and liberating, echoing earlier constructions of video as a force for the good of civil society. Many notions familiar from blue skies cable discourses and alternative video art reappeared in the 1990s as if no one had imagined them before. Online video, Mitchell Kapor argued in a futurecasting *Wired* magazine essay from 1993, would open up the "distribution bottleneck" of TV networks, Hollywood studios, and video stores, granting more access and power to ordinary people. The "unencumbered distribution of video programming of all kinds," he proposed, would serve the public interest better than established commercial institutions, making video at last into "a people's medium."[14] (When YouTube debuted more than a decade later, it was understood according to the same tropes of democratization and participation.) As so often in the twentieth century, during the 1990s, video was understood in terms of its potential to overcome perceived problems of broadcasting-dominant mass media.

By becoming more two way, PC/TV would further depart from its identification as a passive medium in which the audience submits to the control of broadcasters. Two-way television

would be not merely active but interactive, an idea from the culture and rhetoric of personal computers going back to the early 1970s that attached to any technology being married to computers. The interactive user was giving and taking input/output in real time to and from an electronic machine, feeling the full power of the computer entirely under his or her control.[15] The ideological implications of interactivity as a key buzzword of the PC culture of the 1980s and 1990s was to empower ordinary individual users as masters rather than servants of technology, and as newly liberated from the one-way flow of data characteristic of mass-mediated communication. Thus accounts of PC/TV combinations would contrast the image of television's spectators as a mass audience of couch potatoes with the more active individual engagement of computer users.[16] This transformation might also diminish the strength of television's precomputer identity as the familiar set was set on a path of collision with other media and technologies not only in terms of their materiality but also in popular imagination. A report in *Fortune* presented this as a fundamental shift in TV's status, parallel to the upheaval in broadcasting when television was first introduced. "The boob tube we were weaned on is being jacked into the PC and reinvented as a two-way device."[17]

Convergence was another buzzword of this time, in both tech circles and also in the popular press, a phenomenon hyped by manufacturers of computer wares and of consumer electronics such as television sets and components, as well as executives in the media and telecommunications industries.

Convergence talk took on connotations of techno-utopianism even as it was often acknowledged to be corporate PR razzle-dazzle. In the not-too-distant future, fulfilling many predictions promised during the 1990s, everyday life would be transformed for the better by technological convergence. All of these various industries were to melt into one, the better to serve customers an endless stream of instantaneous and virtually limitless information and entertainment. The key individual elements to converge—the personal computer, television set, and telephone—were to come together in a new form of convenient communication that would be at once interactive and instantaneous. *Wired* portrayed a future in which "a seamless high-speed network" would transmit "voice, data, and video services to everyone."[18] Some of the imagined uses of this convergent technological bundle would be voice and text data transmission, but most typically the future was represented as *multimedia* rather than merely reproducing existing single-media uses. Many of the most bold and breathless predictions for the convergent future described video applications of the TV-computer marriage, particularly two-way videoconferencing in business settings and interactive television in the home.

Some accounts of video under convergence proposed literal ways of mapping the experience of the World Wide Web onto TV programming as a path to transforming video into an interactive medium. For instance, according to some imaginings, an image on the TV screen would be hyperlinked so the viewer might click it for more information, such as the identity and

credits of a familiar-seeming actor or advertising tying in with the program.[19] This innovation remains largely beyond everyday experience, but some forms of literal TV–Internet convergence were actually realized during the mid-1990s. Beginning in 1996, WebTV, a set-top box paired with a subscription, provided Internet service for the home TV as an alternative to a PC and modem. This device would use the TV set as an Internet terminal and was pitched at consumers who wanted to surf the web and send and receive e-mail but were uncomfortable with computers.[20] At the same time, media companies such as TV networks also began to integrate the Internet into marketing and promotion of their content, launching companion websites offering program information and encouraging the television audience to visit them.[21] In all of these examples, the degree of interactivity of these products and uses was seen as merely a prelude to a future in which video itself could be sent and received over the web, gushing through fiber-optic computer network cables. In this kind of use, video sheds its earlier associations with television and magnetic recording, and becomes a constantly flowing stream of data across global info networks.

An early instance of this deeper integration of video into the web was *Homicide: Second Shift*, which in 1997 was spun off of the NBC police drama *Homicide: Life on the Streets* and billed as "NBC's Premiere Online Series." The two shared a setting and situation, but the web series had its own cast of detectives portrayed in a multimedia format combining text,

audio and video, still images, and animation. During episodes in 1998 and 1999, the web and broadcast series did a number of double crossovers, with cast members and storylines integrating into both web and TV installments.[22] An NBC director of interactive programming hyped one such event as "an actual convergence of entertainment media" rather than a tie-in or promotion.[23] This was received as something of a publicity stunt, but it anticipated later uses of online video as an adjunct to television broadcasts and an extension of television narrative into the new media space of the web.

Most uses of the Internet by broadcast networks in this period were still straightforwardly promotional, aimed at drawing the young, active, hip audiences feared to be abandoning TV for the Internet back to the set. In the mid-2000s, television shows themselves followed promotions and spin-offs online and at the same time, webisodes and other extensions of TV narrative online proliferated. These extensions have always had a promotional function, as the Hollywood studios claimed in 2007 and 2008 during a labor dispute over digital media residuals, but they also serve to diminish the centrality of the television broadcast as a text and to expand web video's presence and cultural force. The proliferation of video streaming online might serve as a complement to TV received over the air or by cable or satellite. The networks offer streaming episodes to protect against piracy, to hawk their broadcast product, and to serve advertising online.[24] One effect is to diminish distinctions between broadcast, cable, VOD, streaming, and

downloaded content, particularly among consumers growing up in an environment of convergent media.

Over time, video distributed on the Internet has also become an alternative to TV accessed through its more traditional channels, producing a sense of difference between old and new TV technology and modes of experience that go along with them. This online video distribution includes YouTube, Netflix, Amazon, and iTunes, which might be accessed through web-connected TV peripheral devices such as Apple TV, Roku, and video game consoles. Literally it might mean coming together, but practically speaking convergence has also meant substitution of video for television, as well as television's inclusion within the wider set of practices, texts, and technologies called video. Online video has weakened television's distinctiveness as a medium. It has made possible watching television shows without "watching TV," whatever that might mean. And it has provided a crucial context for the cultural legitimation of some kinds of television programming at once associated with new digital technologies of agency (DVDs, DVRs, the Internet) and perceived to be a departure from the older, less legitimate conception of television from the network era.[25] In delivering on the promise of convergence, though not on all of its more utopian fantasies, networked video has been the occasion for reconsidering many cultural categories.

Digital convergence has particularly intensified the ambiguity in defining television and cinema in relation to one another, and to video. No longer so easily distinguishable

technologically, television and cinema retain many of the cultural associations and practices that contribute to their identity. But these are also threatened by emergent cultural practices and protocols of use associated with new technologies and with Millennial media consumers less invested than older generations in traditional conceptions of media. One way of describing Millennials' uses of media is *platform agnostic* consumption, a term that gained wider currency from a 2007 David Denby trend piece in the *New Yorker* on the changing status of cinema in the digital age. Denby claimed that young people, according to Hollywood "home-entertainment specialists," tend not to distinguish between movies seen in a theater, on a TV or computer screen, or on a mobile device like a video iPod (video-enabled phones were just beyond the horizon in 2007, and tablets were a few years off). A platform agnostic will watch movies on the Internet, on television, on "screens of all sizes," without distinguishing these experiences in terms of value and authenticity. Being able to access content on demand is most important to them.[26] An unstated assumption of this widespread conception of the audience might also be that it is medium agnostic: it does not insist on cinema or television being defined by film or broadcast transmission, respectively. At the time of Denby's writing, film was still projected mainly using film. But that too has changed, making video all the more central to moving-image media.

Denby's stance was that the younger generation's lack of investment in cinema as film projected in a theater posed a

threat to movie culture, but Millennial agnosticism might just as well be seen as a boon to a video culture that includes movies. Feature films and TV shows, along with many other forms of video, have moved freely among platforms and technologies and formats in the digital age, coming to us on theater screens, in browser windows, on DVD and Blu-ray, through cable or satellite VOD, streaming services, iTunes or BitTorrent downloads, and numerous other sources. Cinema's putative loss has been video's gain.

## Video as Cinema Killer

For several decades, cinephiles like Denby have approached video with trepidation. Their status anxiety has manifested itself in a number of ways. When videotape cassettes and laser discs were functioning as substitutes for film exhibition, cinephiles would express concerns about the image's authenticity and legitimacy. They might also defend the space of the movie theater in relation to the home, as Susan Sontag did in her deeply nostalgic 1996 *New York Times* essay "The Decay of Cinema" that replays some of the same scenes from Pauline Kael's essay of three decades earlier:

> You wanted to be kidnapped by the movie—and to be kidnapped was to be overwhelmed by the physical presence of the image. The experience of "going to the movies" was part of it. To see a great film only on television isn't to have really seen that film. It's not only a question of the dimensions of the image: the disparity

between a larger-than-you image in the theater and the little image on the box at home. The conditions of paying attention in a domestic space are radically disrespectful of film. Now that a film no longer has a standard size, home screens can be as big as living room or bedroom walls. But you are still in a living room or a bedroom. To be kidnapped, you have to be in a movie theater, seated in the dark among anonymous strangers.[27]

Cinephiles might also decry the influence of textual forms associated with video, such as "MTV" or "small-screen" aesthetics. Such comparisons are unlikely to be generous toward video, and the agenda is generally the defense of film and the culture surrounding it. As taste is often constructed around distaste, cinema has been defined by its negation of television as an artistic medium and social institution.

These anxieties have often been expressed in a genre of popular early twenty-first-century film writing that one critic dubbed the "Death of Movies" think piece.[28] (Sontag's "Decay of Cinema" essay was a founding instance of this genre.) Conventions of such criticism include faulting contemporary Hollywood's excessive profit seeking and overreliance on digital technologies, questioning the younger generation's cultural habits and preferences, expressing nostalgia for an earlier period of cinephilia when the movies were better and more central to elite culture, and distinguishing between acceptable and unacceptable modes of movie experience. Many such think pieces are premised on a distinction between film and television in terms of cultural value. TV can play the bad guy in

this story (draining film's audience, substituting inferior technology and aesthetics) or less often the good guy (offering a positive alternative to mainstream movies in the form of quality TV dramas and comedies).

One of the most famous of these think pieces was Godfrey Cheshire's "Death of Film/Decay of Cinema," published in the *New York Press* in 1999.[29] This essay has been noted for its prescience in predicting many far-off events at the time of its publication, particularly the shift from photochemical film to digital video in both production and exhibition. The replacement of 35mm film with digital video projection has been widely recognized as a turning point in the history of the movies. Unlike sound, widescreen, 3D, and other technological changes in film history, however, digital projection has not been promoted very heavily as a value-added feature to attract audiences to the theater, and it has probably quite often gone unnoticed by ordinary cinemagoers. But to cinephiles, it has been an occasion for some consternation, perhaps for this very reason. The change might seem all the more insidious, to those objecting to film's coming obsolescence, for going unnoticed. Cheshire articulated many of the pains and stresses of this transition long before digital projection became commonplace.

He correctly predicted that film exhibition would give way to video technology, and he portrayed this dramatically, describing the transition to digital as the "overthrow of film by television." While television broadcasting, film projection,

and digital cinema projection are all technologically distinct in many ways, the association of digital video with TV and its distinction from film produces a rhetorical coupling of video and TV and a break between film and digital video even when projected in a movie theater in high definition. As a consequence of the movie theater's digital conversion, movies of the future would lack the "esthetic singularity [and] cultural centrality" they enjoyed in the twentieth century. Cheshire expressed concern over the effect of the change on the projected image, its quality and effect. The video picture, according to Cheshire, replaces film's solidity with TV's immediacy, denying the audience film's characteristic "perspective and discrimination." Movie culture would consequently face a kind of nomenclature anxiety, uncertain about whether it would still be appropriate to refer to film schools, film festivals, or film criticism. Clearly the identity and continued existence of the medium were at stake in this development. And beyond the qualities of the video image, the forms of content and experience typical of television were also feared likely to encroach onto cinema's turf. Wired for digital video projection, the movie theater of the future would transition into a place to watch satellite or Internet telecasts of live events. "The 'moviegoing' experience," he predicted, "will be completely reshaped by—and in the image of—television." Sporting events, celebrity weddings, and rock concerts would take the place of feature films. Theaters would program episodes of TV shows like the *Seinfeld* finale if the box office prospects were appealing enough.

Some of Cheshire's predictions have come to pass. Movie theaters have found some success screening live performances in high definition, such as operas from the Met in New York City, though this is hardly their main business. Whether the shift to digital projection has spelled such a drastic transformation in movies, however, seems open to discussion. The now-standard format of 2K projection, a considerably higher-resolution picture than the 1080p of HDTV, is harder for most people to distinguish from 35mm film than VHS cassettes, with their 480 lines of standard definition resolution. Still, connoisseurs of the image are quick to recognize differences in color and light, in the texture of the image, in the quality of grain and pixels, and in the potential for film to degrade, suffer scratches and other damage, and to be badly projected. Digital movies have become, in one critic's words, "something new, or something *else*."[30]

What they have become is high-definition digital video, replacing photochemical emulsion and a mechanical apparatus with sensors, pixels, data, servers, files, and software. But there has been a reluctance to call theatrical projection video projection. More commonly the movies' new format is called digital cinema or just "digital."[31] This usage is an elision marking the persistence of cultural hierarchy in which films or movies are above video or television. Still, to some in the artistic community invested in cinema as film, the new format of movies is not merely a technological change but another medium entirely. In a 2012 dialog between its film critics on the subject of the

"revolution" of digital movies, the *New York Times* reviewer A. O. Scott posed these questions: "Will digitally made and distributed moving-picture narratives diverge so radically from what we know as 'films' that we no longer recognize a genetic relationship? Will the new digital cinema absorb its precursor entirely, or will they continue to coexist?"[32] Quentin Tarantino would likely vote against absorption, proclaiming his intention to stop directing features for theatrical release before shooting them digitally—"I hate that stuff"—for digital exhibition, or as he calls it, "television in public."[33]

Digital cinema and digital television are not typically considered together, but a comparison reveals an inversion in terms of cultural status and place in popular imagination during the era of digital convergence. The expansion of video in the digital age to include movies and television among other forms of media has been understood as a significant upgrade for TV and a threat to the very existence of cinema. Digital television has been framed in terms of democratization, expansion of access, and new opportunities for aesthetic progress such as more "complex" storytelling, or Netflix's strategy of releasing all thirteen episodes of a TV season at once for "nonlinear" consumption.[34] The new technological ensembles for television distribution and consumption have been seen as sources of liberation and legitimation. This is framed against television's network-era history as a mass medium characterized by limited choices of "least objectionable programming." By contrast with its earlier status, TV in the convergence era has seen

significant improvement in its place on the cultural hierarchy. Movies, on the other hand, have suffered to some extent. TV and movies are both negotiating new identities, but only for movies is it often portrayed as a degradation. There have been some rumblings about the "death of television," but this can be represented hopefully, even excitedly, breaking the control of the broadcasting institutions when web video technologies such as YouTube are seen to be "exploding TV."[35] The death of cinema discourse, by contrast, conveys a much different affect. Rueful and valedictory, it conveys cinephiles' chagrin over the decline and loss of a cherished film culture.

In some important ways, the digital age has merely continued and intensified discourses that circulated before computers and media began to converge. The ideas about television, cinema, and video from the era of videotape formed a foundation of meaning for later understandings of these categories. Conceptions of passivity and activity, of authenticity and aesthetic value, have been important throughout phases two and three. But the digital age has also introduced new meanings and ambiguities, pushing all of these categories closer to one another even as they might attempt to form new lines of distinction, and making video all the more central to cultures of the moving image.

# 5
## MEDIUM AND CULTURAL STATUS

**Having considered** a number of historically specific conceptions of one medium over several decades of technological and cultural change, I now want to step back and look at the medium as a concept that has been present throughout these discussions, though often in the background. What insights does video offer into the ways a medium is constituted?

(Before proceeding further, a note on terminology. In these concluding points I am using *media* strictly as the plural of *medium*, rather than as the name for the whole category of technologies of representation and the institutions that support them. *Mediums* is clumsy and some will object that media is already plural, but if it helps, think mediums.)

First of all: as should be abundantly evident, video is not one thing. It is not CRTs, or videotape, or web television, or digital cinema. It can be any or all or none of these, but it is

not defined by a particular material form alone. No medium is one thing. Film and television and books and sound recordings are also constituted by many technologies and materials, whose uses and meanings are historically specific and contextual. Media are historically contingent and mutable concepts. At a particular moment in time, a medium might take a specific material form, but a medium cannot be fixed in a particular moment from the standpoint of considering its cultural identity. In video's case, the introduction of new technological ensembles has not meant the erasure of earlier meanings. For instance, the association of video with television broadcasting has never gone away even when its uses have moved away from TV. The persistence of residual medium nomenclature such as documentary film (shot on video, made for television) or celebrity sex tape (recorded to a microchip, streamed on the Internet) reveals investments in medium categories and concepts, and their relative cultural status, independent of material format. These investments are evidence of a kind of thinking I have described a number of times in the preceding chapters that we might call *mediumism*, a bias for or against one medium or another on the basis of ideological assumptions about its technological essence and ideal uses. Film and tape are not equal, equivalent, or interchangeable terms, but tokens of larger systems of meaning and value with their own often intertwined histories.

Video's identity is a product of its materiality. It is not produced by this alone, though, but always in relation to other

factors. Changes in video's identity can be charted by changes in video technology. Video was different when it could be recorded than it had been before. It was different when consumers could use it in the street or at home. It was different when movies were widely accessible for sale or rental on cassette. And it was different when it could be shared online. But it was also different when it was understood in relation to radio, television, film, records, photography, and computers. It was different when TV was viewed positively than it was when TV was viewed negatively. When it was valued highly or not, when it was associated with beneficial and harmful social changes, and with audiences of greater or lesser gender or class status, video shifted its identity. All of these factors are necessary for understanding video as a medium, but no one can be sufficient.

As this historical account shows, the medium can be a contentious category precisely because it can be hard to grasp just what it names, describes, and includes or excludes. Is it a particular material or technological form, or can it include a variety of such things? Is painting a medium, or do we have to get more specific: oil, acrylic, gouache? Are half-inch, Betamax, DVD, and Flash video each a medium of their own, with their own uses and meanings? One way out of this levels-of-specificity problem that has been attractive to some scholars of video is to substitute the terms *format* or *platform* for *medium* in some instances.[1] A format such as VHS tapes or MP3 sound files or a platform such as a Wii game console might be a more

productive level for analysis than the more vague and variable concept of the medium. An interest in format and platform study, while still fairly new, has generated some compelling new media scholarship attentive at once to technology, aesthetics, and cultural practice.[2] But as a cultural category as well as an object of scholarly inquiry, medium retains its salience precisely because it has a social identity and a place within wider frames of reference and meaning. Producers and consumers of movies, TV, etc., find it useful to think in terms of media (as well, of course, as formats and platforms) and to categorize and understand mediated representations and technologies of mediation at the level of the medium. For higher-level categories such as video, medium thinking is practically unavoidable, though I would not preclude using medium as well for lower-level categories such as VHS. To think of video and its various material forms as media is to take into account a range of technological, formal, and social components, which we can break down into a number of levels for purposes of analysis.

As a cultural category, video is partly stuff and partly ideas about stuff. In the previous discussion, I emphasized ideas over stuff, though both are essential. But because we only ever experience a medium through discourse—forms of knowledge and ways of speaking about them—we cannot know the materials of media directly or innocently. Particularly if our interest is in the social circulation of media, our attention to the prevailing ways of thinking about them will be essential in apprehending their meaning and significance.

There are many ways of approaching media and of making sense of them. A more aesthetic or technical approach might find that an emphasis on ideas and their social significance misses what's most interesting and important. My intention is not to vote up one approach at the expense of another but merely to offer the cultural view as one way of understanding media that I think explains some important things well. It cannot explain everything we might want to understand.

In particular, the cultural view helps us appreciate how video is constituted in relation to the two other media with which it often overlaps: cinema and television. Video has been a medium of TV and a medium of cinema. It has also been a medium whose identity has been distinguished from TV and from cinema. If it is possible for video to have been all of these things, this suggests that movies and TV, no more or less than video, can also be understood relationally and contingently, and that we err in overemphasizing the significance of stuff in our conception of media, or at least of these three media.

To get more fine grained: we can think of media having identities at different levels of specificity and materiality, all of which might be seen as overlapping and interconnecting. There is the level of the technology, which is not historically constant but rather always potentially in flux. This technology is partially available to the user and partially hidden, black boxed. The user of a VHS cassette, for instance, handles plastic, reads labels, and presses buttons, but the recording itself is rather opaque, and the details of how the heads read the tape

and cause an image made up of scan lines of light and color to appear on the screen are not important or legible to the ordinary user, even if their experience is of a medium defined in part by those things. (A recent nostalgia for VHS in online cultures sharing glitchy GIFs of analog video images celebrates the materiality of the VHS medium and its visual flaws and failures. Participants are undoing the black-boxing of the technology in ways that reveal how during ordinary use we might not appreciate the medium as a technology but rather as a means of accessing content.)

Beyond technology, the concept of the medium also includes typical or authorized formats, genres, and other textual qualities. Nothing about the televisual apparatus necessitates live transmission or certain kinds of camera technique, but these are also part of the identity of the medium in some contexts. We think of television as a medium that includes such things as series and broadcasts and communal experience. These are standard uses of television rather than hardware. They are not the medium's essence.

As Lisa Gitelman has argued, a medium is understood not only as a technological form but also a set of supporting protocols, which she describes as "norms about how and where one uses it."[3] Video has had many of these protocols, which are themselves also historically contextual and changing. These protocols, which also might include technological affordances and ideas about them, inform the status of the medium and its typical place in the everyday lives of ordinary

people. Protocols of video use at different times might have included watching TV at home after work, or recording favorite TV shows for later consumption, or choosing a feature film from the neighborhood video store to watch on a Saturday night, or making home movies of birthdays and vacations, or sharing a link to a YouTube clip. We might define video by its various affordances: documenting reality, making art to critique mass media using its own tools of expression, or making movie watching more convenient.

Finally, on the most abstract and societal level, media have socially circulating identities informed by all of these technological and social factors, which is what I have been calling cultural status. Video is a medium of promise and also of corruption, of democratization but also of threats to society, of mass audience reception but also of masculine tech-fetish connoisseurship, of authentic representation but also of inauthentic facsimiles of real representations. The cultural status of video has been shifting and contradictory, and has spoken to prevailing social needs and anxieties. It has been particularly sensitive to the relationality of video to movies, TV, and other proximate media. And it has often revealed most of all the status of television as society's most dominant communications institution and source of information and entertainment. Where video's status has been either positive or negative, it has been by association with or by contrast against television.

Thinking of video in terms of its cultural status is not so novel. Television historians in particular have shown an

interest in appreciating TV's cultural status, particularly in its emergence as a new medium. In *Make Room for TV*, Lynn Spigel identifies popular conceptions of television and its contradictory place in American life in the 1950s through reading women's magazines, television programs, and other relevant historical discourses.[4] William Boddy's *New Media and Popular Imagination* offers a number of accounts of the formation of the cultural status of radio, television, and digital media such as DVRs particularly in terms of their class, gender, and national identity.[5] Closer to the topic of this work, Joshua Greenberg's *From Betamax to Blockbuster* considers the history of video stores in terms of the development of the VCR from a time-shifting device for TV shows into a medium for watching movies, revealing the centrality of cultural intermediaries for the social construction of technology.[6] In making these points, I have aimed for similar consideration of video as a new (and perpetually renewed) medium, looking at several moments in its history in terms of its place in popular imagination. By thinking in terms of cultural status, we can look at the shifting histories of many media and cultural forms and think about their constitution in relation to dominant institutions and practices and their meanings.

Yet understanding media as being constituted in part by their cultural status runs counter to much of the mediumist thinking about this category and concept, thinking that may help explain why some scholars would prefer not to talk of the medium at all. Marshall McLuhan and followers of

his such as Neil Postman articulate an idea of the medium as a formidable force in its own right.[7] They hold that the medium produces specific, powerful effects on society by force of its technological or sensory qualities. David Jay Bolter and Richard Grusin's *Remediation* insists on the constrained and hybrid agency of media, avoiding the charge McLuhan standardly faces of technological determinism. But their McLuhanesque definition of a medium as "that which remediates," i.e., which "appropriates the techniques forms, and social significance of other media," is ultimately centered more on technologies and the textual forms and representations produced for them than on a medium's social uses and protocols, or ideas about its cultural status and place in popular imagination.[8] In a quite different way, more aesthetically based theories in art history and film and video studies also assume that the medium, as defined by its material or technological qualities, can be appreciated best by giving attention to its specificity and praising the specific artistic works that best exploit the qualities deemed specific to it. In some ways the agenda of much of the history of film theory, from the days of silent cinema as a new art form through sound-era realism and apparatus theory, has been to identify the essence of the cinematic medium and often as well the uses of cinema that best fulfill the promise of its technical properties.

My agenda here is not to quarrel with these conceptions of the medium, each of which has been productive for thinking about art, culture, representation, and society—and about

video in particular. But I do want to point out that when taking the cultural view, it may be necessary to suspend the idea of the medium exerting its own force of agency, and to put aside the aesthetic investment in medium specificity as the key to understanding artistic achievement and progress. The cultural view, rather, reveals the imbrication of media and the inadequacy or irrelevance of strict medium definitions for some purposes and understandings. Media themselves are not literally in competition with one another (though some forces would like to promote one at another's expense—e.g., claiming that the Internet is taking over television). It can be hard even to distinguish them from one another. When taking a cultural view of video, we see that the medium does not always effectively mark itself off from film, television, and other media. In certain historical moments, it makes more sense to think of the uses of video in relation to certain other cultural practices, such as making home movies or artworks. Home movies is an example of a category that admits both film and video, and to appreciate the cultural rather than the technical significance of home movies we cannot insist on a hard line of distinction between the media. This is often true of media, which borrow constantly from one another and often have much more in common than champions or detractors of some medium in particular would admit.

So to return to the questions of what video reveals about the medium as such: taking the cultural view, video has been many forms of moving image technology, expression, and experience. It has shifted its identity according to its varying

material forms and formats, but also according to social needs and desires, and in answer to the hopes and fears projected on it. It has also shifted as the word itself has referred to different things for different people at different times. As a cultural concept, a medium such as video is a cluster of ideas, historically contingent and located in the relationality of media, about the possibilities of technologies and their meanings in the context of everyday life and lived social relations. That there have been so many video revolutions—from the advent of television to the mobile and social video revolutions of the 2010s—should tell us that there have also been many videos, overlapping and recurring but also contradictory and distinct. High-tech consumer electronics hype demands revolution talk, but notions of dramatic change also allow for expressions of a society's dissatisfaction with the status quo and of its fantasies of a better (or worse) life to come. In many of its various iterations, video has answered these needs.

# NOTES

## Preface

1. Carolyn Marvin, *When Old Technologies Were New: Thinking About Electric Communication in the Late Nineteenth Century* (New York: Oxford UP, 1988), 8, argues: "Media are not fixed natural objects; they have no natural edges. They are constructed complexes of habits, beliefs, and procedures embedded in elaborate cultural codes of communication." Philip W. Sewell, *Television in the Age of Radio: Modernity, Imagination, and the Making of a Medium* (New Brunswick, N.J.: Rutgers UP, 2014), 49, argues that a medium is not only a technology but also "a set of articulated social relations, values, institutions, and gadgets."

2. James W. Carey and John J. Quirk, "The Mythos of the Electronic Revolution," in *Communication as Culture: Essays on Media and Society*, ed. James W. Carey (New York: Routledge, 1992), 113–141.

3. Thomas Streeter, "Blue Skies and Strange Bedfellows: The Discourse of Cable Television," in *The Revolution Wasn't Televised: Sixties Television and Social Conflict*, eds. Lynn Spigel and Michael Curtin (London: Routledge, 1997), 221–242.

4. Vincent Mosco, *The Digital Sublime: Myth, Power, and Cyberspace* (Cambridge, Mass.: MIT P, 2005).

5. Evgeny Morozov, *To Save Everything Click Here: The Folly of Technological Solutionism* (New York: PublicAffairs, 2013).

6. Raymond Williams, *Keywords: A Vocabulary of Culture and Society* (New York: Oxford UP, 1976), 229.

7. Will Oremus, "Apple's New iPhones Go Heavy on Hardware, Light on Gimmicks," *Slate Future Tense*, September 10, 2013.

## 1. Three Phases

1. Video has been the subject of numerous scholarly books and articles, many of which have grappled with some of these particular "fantasies" about video according to certain conceptions of the medium or in particular moments of its history. Notable examples are Rosalind Krauss, "Video: The Aesthetics of Narcissism," *October* 1 (Spring 1976): 50–64; Roy Armes, *On Video* (London: Routledge, 1988); Sean Cubitt, *Timeshift: On Video Culture* (London: Routledge, 1991); James Moran, *There's No Place Like Home Video* (Minneapolis: U of Minnesota P, 2002); and Yvonne Spielmann, *Video: The Reflexive Medium* (Cambridge, Mass: MIT P, 2010).

2. Marita Sturken and Douglas Thomas, "Introduction: Technological Visions and the Rhetoric of the New," in *Technological Visions: The Hopes and Fears That Shape New Technologies*, eds. Thomas Sturken and Sandra J. Ball-Rokeach (Philadelphia: Temple UP, 2004), 1–18.

3. With Elana Levine, I have argued that television's cultural status has shifted during the era of digital convergence to a more legitimated level on the cultural hierarchy. It is in this sense that I am using "cultural status" in explaining the cultural view. Michael Z. Newman and Elana Levine, *Legitimating Television: Media Convergence and Cultural Status* (New York: Routledge, 2012).

4. I am using "popular imagination" following William Boddy, *New Media and Popular Imagination: Launching Radio, Television, and Digital Media in the United States* (New York: Oxford UP, 2004).

## 2. Video as Television

1. Sidney Lohman, "News of TV and Radio: Video's Impact on Radio—Other Studio Items," *New York Times*, December 7, 1952, X17.

2. Orrin E. Dunlap, Jr., *The Outlook for Television* (New York: Harper & Row, 1932; reprinted by New York: Arno Press, 1971), 4.

3. Philip W. Sewell, *Television in the Age of Radio: Modernity, Imagination, and the Making of a Medium* (New Brunswick, N.J.: Rutgers UP, 2014) 41.

4. Jerry Fairbanks, "Film's Role in Video: It Helps to Increase New Medium's Flexibility," *New York Times*, June 13, 1948, XX20. For more on usage of video in the 1950s and 1960s, see John Belton, "Looking Through Video: The Psychology of Video and Film," in *Resolutions: Contemporary Video Practices*, eds. Michael Renov and Erika Suderberg (Minneapolis: U of Minnesota P, 1996), 61–72.

5. Sewell, *Television in the Age of Radio*, 33–34.

6. Gilbert Seldes, *The Great Audience* (New York: Viking, 1950), 190.

7. David Weinstein, "Captain Video: Television's First Fantastic Voyage," *Journal of Popular Film and Television* 30, 3 (Fall 2002): 148–157.

8. William Boddy, *Fifties Television: The Industry and Its Critics* (Champaign: U of Illinois P, 1990).

9. Quoted in Frederick Wasser, *Veni, Vidi, Video: The Hollywood Empire and the VCR* (Austin: U of Texas P, 2001), 55.

10. Ibid., 53.

11. Alexander Russo, "Defensive Transcriptions: Radio Networks, Sound-on-Disc Recording, and the Meaning of Live Broadcasting," *The Velvet Light Trap* 54 (Fall 2004), 4–17; Alexander Russo, *Points on the Dial: Golden Age Radio Beyond the Networks* (Durham, N.C.: Duke UP, 2010), 77–114.

12. Russo, *Points on the Dial*, 84.

13. Fairbanks, "Film's Role in Video," *New York Times*, June 13, 1948, XX20.

14. Jane Feuer, "The Concept of Live Television: Ontology as Ideology," in *Regarding Television: Critical Approaches—An Anthology*, ed. E. Ann Kaplan (Los Angeles: American Film Institute, 1983), 12–21.

15. Edwin Diamond, "TV View: Is Live Television a Dead Issue?" *New York Times*, November 12, 1978, D41.

16. John Ellis, *Visible Fictions: Cinema, Television, Video* (New York: Routledge, 1982), 132, 134.

17. Jack Gould, "A Plea for Live Video: Switch to Film for TV Was a Major Mistake," *New York Times*, December 7, 1952, X17.

18. Elana Levine, "Distinguishing Television: The Changing Meanings of Television Liveness," *Media, Culture & Society* 30, 3 (2008): 393–409.

## 3. Video as Alternative

1. On the history of videotape's development see Albert Abramson, *The History of Television, 1942–2000* (Jefferson, N.C.: McFarland & Company, 2003), 60–76; Christoph Blase, "Welcome to the Labyrinth of Machines: Tapes and Video Formats 1960–1980," in *Record Again! 40Yearsvideoart.de* part 2, eds. Blase and Peter Weibel (Ostfildern, Germany: Hatje Cantz/Zentrum für Kunst und Medientechnologie Karlsruhe, 2010), 500–508; and Lucas Hilderbrand, *Inherent Vice: Bootleg Histories of Videotape and Copyright* (Durham, N.C.: Duke UP, 2009), 33–72.

2. Rudy Bretz, "Video Tape: A TV Revolution," *The Quarterly Review of Film Radio and Television* 11, 4 (Summer 1957): 399–415; 401.

3. Jack Gould, "Miraculous Ribbon of TV," *New York Times*, June 28, 1959, SM14.

4. Bretz, "Video Tape," 412; Jeff Martin, "The Dawn of Tape: Transmission Device as Preservation Medium," *The Moving Image* 5, 1 (Spring 2005): 45–66; 49.

5. Oscar Godbout, "N.B.C. to Record with Video Tape," *New York Times*, November 5, 1957, 51.

6. John Fink, "Use Videotape to 'Save Time' on TV Shows," *Chicago Tribune*, November 17, 1957, N14; Larry Wolters, "Tape Produces Revolution in TV Broadcasts," *Chicago Tribune*, August 31, 1958, NW6.

7. "Is TV Tape Live or Film?" *Broadcasting*, October 5, 1959.

8. Walter Lippmann, "Television: Whose Creature, Whose Servant?" in *The Essential Lippmann: A Political Philosophy for Liberal Democracy*, eds. Clinton Rossiter and James Lare (New York: Random House, 1963), 411–413.

9. Bret Maxwell Dawson, "TV Repair: New Media 'Solutions' to Old Media Problems" (PhD diss., Northwestern University, 2008), 113–187.

10. "Magnetic Devices Collect a Record Audience," *New York Times*, September 5, 1958, 35.

11. "Fast Growth Shown by Videotape Market," *Chicago Tribune*, September 23, 1968, C7.

12. J. Robert McAdam, *Portable Video Tape Recorder: A Guide for Teachers* (New York: Division of Educational Technology, National Education Association, 1968).

13. "Videotape—The View from '70" *Business Screen*, April 1970, 29–30.

14. "VTR Adds Punch to Maytag Marketing," *Business Screen*, November 1970, 60–61.

15. "Television on a Disk," *Time*, September 18, 1970.

16. Nadine Subotnik, "Channel Comment," *The Cedar Rapids Gazette*, April 26, 1959.

17. Martin, "The Dawn of Tape," 54.

18. For a first-person account of the introduction of these techniques, see Tony Verna, *Instant Replay—The Day That Changed Sports Forever* (Beverly Hills, Calif.: Creative Book Publishers International, 2008).

19. Leonard Shecter, "Why It's Better to Watch the Game on TV," *New York Times*, March 3, 1968, SM32.

20. Ibid.

21. Thomas Streeter, "Blue Skies and Strange Bedfellows: The Discourse of Cable Television," in *The Revolution Wasn't Televised: Sixties Television and Social Conflict*, eds. Lynn Spigel and Michael Curtin (London: Routledge, 1997), 221–242.

22. Edward Kern, "A Good Revolution Goes on Sale," *Life*, October 16, 1970, 47.

23. Dawson, "TV Repair," 117–121.

24. This history of formats and the companies bringing them to market is well told in James Lardner, *Fast Forward: Hollywood, The Japanese, and the Onslaught of the VCR* (New York: W. W. Norton, 1987).

25. Max Dawson, "Home Video and the 'TV Problem': Cultural Critics and Technological Change," *Technology and Culture* 48, 3 (July 2007): 524–549; 533.

26. Roger Kenneth Field, "In the Sixties It Was TV; In Seventies, Video Cassette," *New York Times*, July 5, 1970, 73.

27. Michael Z. Newman and Elana Levine, *Legitimating Television: Media Convergence and Cultural Status* (New York: Routledge, 2012), 129–152.

28. Charles Burck, "Goldmark's Variations on a Video Theme," *Fortune*, May 1970, 71.

29. George Movshon, "The Video Revolution," *Saturday Review*, August 8, 1970, 50–52.

30. Quoted in Frederick Wasser, *Veni, Vidi, Video: The Hollywood Empire and the VCR* (Austin, Tex.: U of Texas P, 2001), 72.

31. "How the Two Big TV Toys Are Faring," *Broadcasting*, January, 24, 1977, 80.

32. Robert Chew, "Innovations in Video—Nightmare for Networks?" *Advertising Age*, May 30, 1977, 3, 70.

33. Hans Magnus Enzensberger, *The Consciousness Industry: On Literature, Politics and the Media* (New York: Seabury P, 1974), 97.

34. Peter Ross Range, "The Space-Age Pinball Machine," *New York Times Magazine*, September 15, 1974; "Modern Living: Screen Games," *Time*, May 22, 1972; Larry Steckler, "TV Games at Home," *Radio Electronics*, December 1975, 29–31, 71, 90–91; 29; Dick Pietschmann, "The New Fun World of Video Games," *Mechanix Illustrated*, January 1975, 36, 92; 36.

35. Sheila C. Murphy, *How Television Invented New Media* (New Brunswick, N.J.: Rutgers UP, 2011), 41–58.

36. Jason Wilson, "'Participation TV': Videogame Archaeology and New Media Art," in *The Pleasures of Computer Gaming: Essays on Cultural History, Theory, and Aesthetics*, eds. Melanie Swalwell and Jason Wilson (Jefferson, N.C.: McFarland & Co., 2008), 94–117.

37. Blase, "Welcome to the Labyrinth of Machines," 501.

38. Ben Keen, "'Play it Again, Sony': The Double Life of Home Video Technology" *Science as Culture* 1, 1 (1987): 7–42.

39. Dawson, "TV Repair," 174.

40. Douglas Davis, "Television's Avant-Garde," *Newsweek*, February 9, 1970, 60–62.

41. Bill Viola, "Video as Art," *Journal of Film and Video* 36, 1 (Winter 1984): 36–41; 39.

42. Quoted in Sara Hornbacher, "Editor's Statement: Video: The Reflexive Medium, *Art Journal* 45, 3 (Autumn 1985): 191–193; 192.

43. Deirdre Boyle, "From Portapak to Camcorder: A Brief History of Guerrilla Television," *Journal of Film and Video* 44, 1–2 (Spring–Summer 1992): 67–79.

44. Les Levine, "One-Gun Video Art," in *New Artists Video*, ed. Gregory Batecock (New York: E. P. Dutton, 1978), 76–94; 90.

45. William Boddy, "Alternative Television in the United States," *Screen* 31, 1 (Spring 1990): 91–101; 92.

46. David Antin, "Video: The Distinctive Features of the Medium," in *Video Culture: A Critical Investigation*, ed. John G. Hanhardt (Rochester, N.Y.: Visual Studies Workshop Press, 1986), 147–166; 148. Originally published in *Video Art* (Philadelphia: Institute of Contemporary Art, 1975), 57–72.

47. Ibid., 153.

48. Calvin Tomkins, "Video Visionary," *The New Yorker*, May 5, 1975, 44–79; 44.

49. Grace Glueck, "Videotape Replaces Canvas for Artists Who Use TV Technology in New Way," *New York Times*, April 14, 1975.

50. John J. O'Connor, "TV: Video at the Whitney," *New York Times*, June 3, 1976.

51. Barbara Delatiner, "TV as a Tool for the Artist," *New York Times*, February 13, 1977.

52. Nancy L. Ross, "The Home Television Revolution," *Washington Post*, January 26, 1973.

53. "For Many, TV Tape Means Watching More—and Loving It," *New York Times*, August 27, 1977.

54. Vincent Canby, "Confessions of a VCR Recruit," *New York Times*, November 24, 1985.

55. "For Many, TV Tape Means Watching More—And Loving It." *New York Times*.

56. Robert Lindsey, "Hollywood Moves to Tap Video Market," *New York Times*, July 2, 1979.

57. Aljean Harmetz, "A Night at the Movies—At Home on Tape," *New York Times*, March 1, 1978.

58. Keen, "'Play It Again, Sony.'"

59. James Lardner, "I-The Betamax Case," *The New Yorker*, April 6, 1987, 45–71; James Lardner, "II-The Betamax Case," *The New Yorker*, April 13, 1987, 60–81.

60. Lardner, "I-The Betamax Case," April 6, 1987, 57.

61. Lindsey, "Hollywood Moves to Tap Video Market."

62. William Bates, "How a 'Video Revolution' Is Shaping the Future of Film," *New York Times*, November 23, 1980.

63. Joan Kron, "The Media Room," *New York*, April 19, 1976.

64. Lynn Spigel, *Make Room for TV: Television and the Family Ideal in Postwar America* (Chicago: U of Chicago P, 1992).

65. Eric Gelman et al., "The Video Revolution" *Newsweek*, August 6, 1984, 50–57; 51.

66. Ibid., 54–55.

67. Ibid.

68. Many video stores sold popcorn and other cinema snacks, and Orville Redenbacher offered a version of its product called "Video Popcorn" in the later 1980s. Joshua M. Greenberg, *From Betamax to Blockbuster: Video Stores and the Invention of Movies on Video* (Cambridge, Mass.: MIT P, 2008), 82–84.

69. Chuck Kleinhans, "The Change from Film to Video Pornography: Implications for Analysis," in *Pornography: Film and Culture*, ed. Peter Lehman (New Brunswick, N.J.: Rutgers UP, 2006), 154–167.

70. Wasser, *Veni, Vidi, Video*, 94.

71. Keir Keightley, "'Turn it Down!' She Shrieked: Gender, Domestic Space, and High Fidelity, 1948–59," *Popular Music* 15, 2 (1996): 149–177.

72. Cynthia Cockburn, "The Circuit of Technology: Gender, Identity and Power," in *Consuming Technologies: Media and Information in Domestic Spaces*, eds. Roger Silverstone and Eric Hirsch (London: Routledge, 1992), 18–25.

73. Ann Gray, *Video Playtime: The Gendering of a Leisure Technology* (London: Routledge, 1992), 26; 164–180.

74. Greenberg, *From Betamax to Blockbuster*, 37–40, considers *The Videophile* in more detail.

75. "New Magazine: Video Today," *New York Times*, August 27, 1980.

76. Barbara Klinger, *Beyond the Multiplex: Cinema, New Technologies, and the Home* (Berkeley: U of California P, 2006). See also Barbara Klinger, "The New Media Aristocrats: Home Theater and the Domestic Film Experience," *The Velvet Light Trap* 42 (Fall 1998): 4–19.

77. Pauline Kael, "Movies on Television," *The New Yorker*, July 3, 1967, 120–134.

78. Greenberg, *From Betamax to Blockbuster*, 134–141.

79. Charles R. Acland, "Tampering with the Inventory: Colorization and Popular Histories," *Wide Angle* 12, 2 (1990): 12–20.

80. Richard T. Jameson, "Life with Video," *Film Comment* (May 1991): 44–45.

81. Charles Tashiro, "Videophilia: What Happens When You Wait for It on Video," *Film Quarterly* 45, 1 (Autumn 1991): 7–17.

82. Jameson, "Life with Video"; George Mannes, "Life with Video: Video Visions of Light," *Film Comment* (January 1993): 72–75; Tim Lucas, "Life with Video: Who Framed Edward Scissorhands?" *Film Comment* (March 1992):

75–76; Frank Thompson, "Life with Video: Big," *Film Comment* (March 1992): 77.

83. Paolo Cherchi Usai, "The Unfortunate Spectator," *Sight & Sound* 56 (Summer 1987): 170–173.

84. Thompson, "Life with Video: Big."

85. Society for Cinema Studies Task Force on Film Integrity, "Statement on the Use of Video in the Classroom," *Cinema Journal* 30, 4 (Summer 1991): 3–6.

86. Ibid.

87. Ibid.

88. Bruce Kawin, "Late Show on the Telescreen: Film Studies and the Bottom Line," *Film Quarterly* 42, 2 (Winter 1988–89): 56–60.

89. Shyon Baumann, *Hollywood Highbrow: From Entertainment to Art* (Princeton, N.J.: Princeton UP, 2007); Barbara Wilinsky, *Sure Seaters: The Emergence of Art House Cinema* (Minneapolis: U of Minnesota P, 2001). I discuss the cultural significance of film festivals and art house theaters in Michael Z. Newman, *Indie: An American Film Culture* (New York: Columbia UP, 2011), 48–83.

90. *Saturday Night Live* (NBC, 1975– ), episode originally aired February 9, 1980.

91. Tom Shales, "The Abscam Tapes on TV," *Washington Post,* October 15, 1980, B1.

92. Stuart Weiss, "Home Video: The Next Wave," *Business Week*, August 19, 1985, 112–113. On the democratizing rhetoric that often accompanies the introduction of new technologies "that afford expressive capabilities," see Zizi Papacharissi, *A Private Sphere: Democracy in a Digital Age* (Cambridge, UK: Polity, 2010), 3.

93. Similarly, Laurie Grindstaff, "Class, Trash and Cultural Hierarchy," in *The Media Studies Reader,* ed. Laurie Ouellette (New York: Routledge, 2012), 407–426; 415, argues that appearing on a "trashy" talk show gives working-class people opportunities to participate in media discourse. She writes that "the mere act of conveying a message is more important than…what gets said."

94. H. F. Waters, "America's Ugliest Home Videos," *Newsweek,* June 15, 1992, 59.

95. Greg Luft, "Camcorders: When Amateurs Go after the News," *Columbia Journalism Review* (September/October 1991): 35–37.

96. Laurie Ouellette, "Camcorder Do's and Don'ts: Popular Discourses on Amateur Video and Participatory Television," *The Velvet Light Trap* 36 (Fall 1995): 33–44.

97. Cliff Roth, "Back from the Depths," *Dealerscope Merchandising* 34, 12 (December 1992): 34.

98. Waters, "America's Ugliest Home Videos."

99. Jon Dovey, "Camcorder Cults," in *The Television Studies Reader*, eds. Robert C. Allen and Annette Hill (London: Routledge, 2004), 557–568; 557.

100. Luft, "Camcorders."

101. On the interpretive flexibility of technological artifacts, a key term in the social construction of technology approach within science and technology studies and communication studies, see Trevor J. Pinch and Wiebe E. Bijker, "The Social Construction of Facts and Artefacts: Or How the Sociology of Science and the Sociology of Technology Might Benefit Each Other," *Social Studies of Science* 14, 3 (1984): 399–441.

## 4. Video as the Moving Image

1. I wrote about my own history of acquiring and discarding media technology in Michael Z. Newman, "To All the VCRs I've Loved Before," *Zigzigger*, August 6, 2013.

2. Diane Garrett, "VHS, 30, Dies of Loneliness," *Variety*, November 14, 2006.

3. David Bordwell, *Pandora's Digital Box: Films, Files and the Future of Movies* (Madison: Wis.: The Irvington Way Institute Press, 2012), 10.

4. For instance, Edward Jay Epstein, *The Big Picture: The New Logic of Money and Power in Hollywood* (New York: Random House, 2005), 19, claims that the revenue from home entertainment was almost five times the theatrical box office in 2003.

5. Caetlin Benson-Allott, *Killer Tapes and Shattered Screens: Video Spectatorship from VHS to File Sharing* (Berkeley: U of California P, 2013), 1.

6. Todd Spangler, "Netflix Streaming Traffic Grew 30% in Last Six Months: Study," *Multichannel News*, April 25, 2012.

7. Jane Feuer, "The Concept of Live Television: Ontology as Ideology," in *Regarding Television: Critical Approaches—An Anthology*, ed. E. Ann Kaplan (Los Angeles: American Film Institute, 1983), 12.

8. Anne Friedberg, "The End of Cinema: Multi-Media and Technological Change," in *Reinventing Film Studies*, eds. Christine Gledhill and Linda Williams (London: Arnold, 2000), 438–452; 439.

9. Walter S. Baer, *Interactive Television: Prospects for Two-Way Services on Cable* (Santa Monica, Calif.: Rand Corporation, 1971).

10. Edward Kern, "A Good Revolution Goes on Sale," *Life*, October 16, 1970, 47.

11. George Movshon, "The Video Revolution," *Saturday Review*, August 8, 1970, 50–52.

12. Vincent Mosco, *Pushbutton Fantasies: Critical Perspectives on Videotex and Information Technology* (Norwood, N.J.: Ablex, 1982).

13. On analog video's material flaws, see Lucas Hilderbrand, *Inherent Vice: Bootleg Histories of Videotape and Copyright* (Durham, N.C.: Duke UP, 2009), 11–16.

14. Mitchell Kapor, "Where Is the Digital Highway Really Heading?," *Wired* 1.03 (1993).

15. Paul Ceruzzi, "From Scientific Instrument to Everyday Appliance: The Emergence of Personal Computers, 1970–1977," *History and Technology* 13 (1996): 1–31.

16. Francis Balle and Sophie Boukhari, "Wedding Bells for Web and TV," *The UNESCO Courier*, November 1999, 43–35; Brian Fenton, "TV/PC Convergence," *Popular Mechanics*, October 1996, 38.

17. Frank Rose, "The End of TV as We Know It," *Fortune*, December 26, 1996, 58.

18. Kapor, "Where is the Digital Highway Really Heading?"

19. Katie Hafner, "TV Meets the Web," *Newsweek*, September 29, 1997.

20. Rose, "The End Of TV As We Know It," *Fortune*, December 26, 1996.

21. Marc Graser, "Play or Pay: Networks Eye New Website Uses," *Variety*, September 14–20, 1998.

22. Caryn Weiner, "Crossover Dreams," *Entertainment Weekly*, April 17, 1998. For a more detailed description of the web series, its production, and its implications for new media aesthetics, see John T. Caldwell, "Second-Shift Media Aesthetics: Programming, Interactivity, and User Flows," in *New Media: Theories and Practices of Digitextuality*, eds. Anna Everett and John T. Caldwell (New York: Routledge, 2003), 127–144.

23. "Detectives to Solve 'Homicide' Case Online and On Air," *Microsoft News Center*, February 1, 1999.

24. Michael Z. Newman, "Free TV: File-Sharing and the Value of Television," *Television and New Media* 13, 6 (November 2012): 463–479.

25. Michael Z. Newman and Elana Levine, *Legitimating Television: Media Convergence and Cultural Status* (New York: Routledge, 2012).

26. David Denby, "Big Pictures: Hollywood Looks for a Future," *The New Yorker*, January 8, 2007.

27. Susan Sontag, "The Decay of Cinema," *New York Times*, February 25, 1996.

28. Richard Brody, "The Movies Aren't Dying (They're Not Even Sick), *The New Yorker* "The Front Row" blog, September 27, 2012. Some examples of death of movies think pieces not referenced elsewhere are Andrew O'Hehir, "Is Movie Culture Dead?" *Salon*, September 28, 2012; David Thomson, "American Movies Are Not Dead: They Are Dying," *The New Republic*, September 14, 2012; David Denby, "Has Hollywood Murdered the Movies?" *The New Republic*, September 14, 2012; and Mark Harris, "The Day the Movies Died," *GQ*, February 2011. While it has a somewhat different focus, similar themes inform Thomas Doherty, "The Death of Film Criticism," *The Chronicle for Higher Education*, February 28, 2010.

29. Godfrey Cheshire, "Death of Film/Decay of Cinema," *New York Press*, December 30, 1999.

30. Matt Zoller Seitz, "R.I.P., The Movie Camera: 1888–2011," *Salon*, October 13, 2011.

31. Bordwell, *Pandora's Digital Box*, 200.

32. Manohla Dargis and A. O. Scott, "Film Is Dead? Long Live Movies: How Digital Is Changing the Nature of Movies," *New York Times*, September 6, 2012.

33. Stephen Galloway and Matthew Belloni, "Director Roundtable: 6 Auteurs on Tantrums, Crazy Actors and Quitting While They're Ahead," *The Hollywood Reporter*, November 28, 2012.

34. On the connection between digital technology and complex storytelling, see chapter 7, "Technologies of Agency," in Newman and Levine, *Legitimating Television*. The thirteen first-season episodes of *House of Cards* were released on Netflix instant streaming on February 1, 2013, with much publicity covering the novelty of the distribution strategy and its relation to the practice of binge-watching recorded television episodes.

35. Bob Garfield, "YouTube vs. Boob Tube," *Wired* 14 (December 2006).

## 5. Medium and Cultural Status

1. Lucas Hilderbrand, *Inherent Vice: Bootleg Histories of Videotape and Copyright* (Durham, N.C.: Duke UP, 2009), 35, proposes that videotape is more accurately considered a format than a medium. Caetlin Benson-Allott, *Killer Tapes and Shattered Screens: Video Spectatorship from VHS to File Sharing* (Berkeley: U of California P, 2013); and Tarleton Gillespie, "The Politics of Platforms," *New Media & Society* 12, 3 (2010) look at video as a platform.

2. Examples include Benson-Allott, *Killer Tapes and Shattered Screens*; Gillespie, "The Politics of Platforms," 347–364; Hilderbrand, *Inherent Vice*; Jonathan Sterne, *MP3: The Meaning of a Format* (Durham, N.C.: Duke UP, 2012); and the Platform Studies series from MIT Press edited by Ian Bogost and Nick Montfort. See Bogost and Montfort, "Platform Studies: Frequently Asked Questions," *Digital Arts and Culture*, December 12–15, 2009.

3. Lisa Gitelman, *Always Already New: Media, History and the Data of Culture* (Cambridge, MA: MIT P, 2006), 5–7.

4. Lynn Spigel, *Make Room for TV: Television and the Family Ideal in Postwar America* (Chicago: U of Chicago P, 1992).

5. William Boddy, *New Media and Popular Imagination: Launching Radio, Television, and Digital Media in the United States* (New York: Oxford UP, 2004).

6. Joshua Greenberg, *From Betamax to Blockbuster: Video Stores and the Invention of Movies on Video* (Cambridge, MA: MIT P, 2008).

7. Marshall McLuhan, *Understanding Media: The Extensions of Man* (Cambridge, Mass.: MIT P, 1964/1994); Neil Postman, *Amusing Ourselves to Death: Public Discourse in the Age of Show Business* (New York: Penguin, 1985/2005).

8. David Jay Bolter and Richard Grusin, *Remediation: Understanding New Media* (Cambridge, Mass.: MIT P, 1999), 78.

# SELECT BIBLIOGRAPHY

Abramson, Albert. *The History of Television, 1942–2000.* Jefferson, N.C.: McFarland & Company, 2003.

Acland, Charles R. "Tampering with the Inventory: Colorization and Popular Histories." *Wide Angle* 12, 2 (1990): 12–20.

Antin, David. "Video: The Distinctive Features of the Medium." In *Video Culture: A Critical Investigation*, edited by John G. Hanhardt, 147–166. Rochester, N.Y.: Visual Studies Workshop Press, 1986.

Armes, Roy. *On Video.* London: Routledge, 1988.

Baer, Walter S. *Interactive Television: Prospects for Two-Way Services on Cable.* Santa Monica, Calif.: Rand Corporation, 1971.

Baumann, Shyon. *Hollywood Highbrow: From Entertainment to Art.* Princeton, N.J.: Princeton UP, 2007.

Belton, John. "Looking Through Video: The Psychology of Video and Film." In *Resolutions: Contemporary Video Practices*, edited by Michael Renov and Erika Suderberg, 61–72. Minneapolis: U of Minnesota P, 1996.

Benson-Allott, Caetlin. *Killer Tapes and Shattered Screens: Video Spectatorship from VHS to File Sharing.* Berkeley: U of California P, 2013.

Blase, Christoph. "Welcome to the Labyrinth of Machines: Tapes and Video Formats 1960–1980." In *Record Again! 40 Yearsvideoart.de* part 2, edited by Blase and Peter Weibel, 500–508. Ostfildern, Germany: Hatje Cantz/Zentrum für Kunst und Medientechnologie Karlsruhe, 2010.

Boddy, William. "Alternative Television in the United States." *Screen* 31, 1 (Spring 1990): 91–101.

Boddy, William. *Fifties Television: The Industry and Its Critics*. Champaign: U of Illinois P, 1990.

Boddy, William. *New Media and Popular Imagination: Launching Radio, Television, and Digital Media in the United States*. New York: Oxford UP, 2004.

Bogost, Ian and Nick Montfort. "Platform Studies: Frequently Asked Questions." *Digital Arts and Culture*, December 12–15, 2009.

Bolter, David Jay and Richard Grusin. *Remediation: Understanding New Media*. Cambridge, Mass.: MIT P, 1999.

Bordwell, David. *Pandora's Digital Box: Films, Files and the Future of Movies*. Madison: Wis.: Irvington Way Institute Press, 2012.

Boyle, Deidre. "From Portapak to Camcorder: A Brief History of Guerrilla Television." *Journal of Film and Video* 44, 1–2 (Spring-Summer 1992): 67–79.

Bretz, Rudy. "Video Tape: A TV Revolution." *The Quarterly Review of Film Radio and Television* 11, 4 (Summer 1957): 399–415.

Caldwell, John T. "Second-Shift Media Aesthetics: Programming, Interactivity, and User Flows." In *New Media: Theories and Practices of Digitextuality*, edited by Anna Everett and Caldwell, 127–144. New York: Routledge, 2003.

Carey, James W. and John J. Quirk. "The Mythos of the Electronic Revolution." In James W. Carey, *Communication as Culture: Essays on Media and Society*, 113–141. New York: Routledge, 1992.

Ceruzzi, Paul. "From Scientific Instrument to Everyday Appliance: The Emergence of Personal Computers, 1970-1977." *History and Technology* 13 (1996): 1–31.

Cheshire, Godfrey. "Death of Film/Decay of Cinema." *New York Press*, December 30, 1999.

Cockburn, Cynthia. "The Circuit of Technology: Gender, Identity and Power." In *Consuming Technologies: Media and Information in Domestic Spaces*, edited by Roger Silverstone and Eric Hirsch, 18–25. London: Routledge, 1992.

Cubitt, Sean. *Timeshift: On Video Culture*. London: Routledge, 1991.

Dawson, Bret Maxwell. "TV Repair: New Media 'Solutions' to Old Media Problems." PhD diss., Northwestern University, 2008.

Dawson, Max. "Home Video and the 'TV Problem': Cultural Critics and Technological Change," *Technology and Culture* 48, 3 (July 2007): 524–549.

Dovey, Jon. "Camcorder Cults." In *The Television Studies Reader*, edited by Robert C. Allen and Annette Hill, 557–568. London: Routledge, 2004.

Dunlap, Orrin E., Jr. *The Outlook for Television*. New York: Harper & Row, 1932; reprinted by New York: Arno Press, 1971.

Ellis, John. *Visible Fictions: Cinema, Television, Video*. New York: Routledge, 1982.

Enzensberger, Hans Magnus. *The Consciousness Industry: On Literature, Politics and the Media*. New York: Seabury P, 1974.

Epstein, Edward Jay. *The Big Picture: The New Logic of Money and Power in Hollywood*. New York: Random House, 2005.

Feuer, Jane. "The Concept of Live Television: Ontology as Ideology." In *Regarding Television: Critical Approaches—An Anthology*, edited by E. Ann Kaplan, 12–21. Los Angeles: American Film Institute, 1983.

Friedberg, Anne. "The End of Cinema: Multi-Media and Technological Change." In *Reinventing Film Studies*, edited by Christine Gledhill and Linda Williams, 438–452. London: Arnold, 2000.

Gillespie, Tarleton. "The Politics of Platforms." *New Media & Society* 12, 3 (2010): 347–364.

Gitelman, Lisa. *Always Already New: Media, History and the Data of Culture*. Cambridge, Mass.: MIT P, 2006.

Gray, Ann. *Video Playtime: The Gendering of a Leisure Technology*. London: Routledge, 1992.

Greenberg, Joshua M. *From Betamax to Blockbuster: Video Stores and the Invention of Movies on Video*. Cambridge, Mass.: MIT P, 2008.

Grindstaff, Laurie. "Class, Trash and Cultural Hierarchy." In *The Media Studies Reader*, edited by Laurie Ouellette, 407–426. New York: Routledge, 2012.

Hilderbrand, Lucas. *Inherent Vice: Bootleg Histories of Videotape and Copyright*. Durham, N.C.: Duke UP, 2009.

Hornbacher, Sara. "Editor's Statement: Video: The Reflexive Medium," *Art Journal* 45, 3 (Autumn 1985): 191–193.

Jameson, Richard T. "Life with Video." *Film Comment* (May 1991): 44–45.

Kael, Pauline. "Movies on Television." *The New Yorker*, July 3, 1967, 120–134.

Kawin, Bruce. "Late Show on the Telescreen: Film Studies and the Bottom Line." *Film Quarterly* 42, 2 (Winter 1988–89): 56–60.

Keen, Ben. "'Play It Again, Sony': The Double Life of Home Video Technology." *Science as Culture* 1, 1 (1987): 7–42.

Kern, Edward. "A Good Revolution Goes on Sale," *Life*, October 16, 1970, 47.

Keightley, Keir. "'Turn It Down!' She Shrieked: Gender, Domestic Space, and High Fidelity, 1948–59." *Popular Music* 15, 2 (1996): 149–177.

Kleinhans, Chuck. "The Change from Film to Video Pornography: Implications for Analysis." In *Pornography: Film and Culture*, edited by Peter Lehman, 154–167. New Brunswick, N.J.: Rutgers UP, 2006.

Klinger, Barbara. "The New Media Aristocrats: Home Theater and the Domestic Film Experience." *The Velvet Light Trap* 42 (Fall 1998): 4–19.

Klinger, Barbara. *Beyond the Multiplex: Cinema, New Technologies, and the Home.* Berkeley: U of California P, 2006.

Krauss, Rosalind. "Video: The Aesthetics of Narcissism." *October* 1 (Spring 1976): 50–64.

Lardner, James. "I-The Betamax Case." *The New Yorker*, April 6, 1987, 45–71.

Lardner, James. "II-The Betamax Case." *The New Yorker*, April 13, 1987, 60–81.

Lardner, James. *Fast Forward: Hollywood, the Japanese, and the Onslaught of the VCR.* New York: W. W. Norton, 1987.

Levine, Elana. "Distinguishing Television: The Changing Meanings of Television Liveness." *Media, Culture & Society* 30, 3 (2008): 393–409.

Levine, Les. "One-Gun Video Art." In *New Artists Video*, edited by Gregory Battcock, 96–94. New York: E. P. Dutton, 1978.

Lippmann, Walter. "Television: Whose Creature, Whose Servant?" In *The Essential Lippmann: A Political Philosophy for Liberal Democracy*, edited by Clinton Rossiter and James Lare, 411–413. New York: Random House, 1963.

Lucas, Tom. "Life with Video: Who Framed Edward Scissorhands?" *Film Comment* (March 1992): 75–76.

Mannes, George. "Life with Video: Video Visions of Light." *Film Comment* (January 1993): 72–75.

Martin, Jeff. "The Dawn of Tape: Transmission Device as Preservation Medium." *The Moving Image* 5, 1 (Spring 2005): 45–66.

Marvin, Carolyn. *When Old Technologies Were New: Thinking About Electric Communication in the Late Nineteenth Century.* New York: Oxford UP, 1988.

McLuhan, Marshall. *Understanding Media: The Extensions of Man.* Cambridge, Mass.: MIT P, 1964/1994.

Moran, James. *There's No Place Like Home Video.* Minneapolis: U of Minnesota P, 2002.

Mosco, Vincent. *Pushbutton Fantasies: Critical Perspectives on Videotex and Information Technology.* Norwood, N.J.: Ablex, 1982.

Mosco, Vincent. *The Digital Sublime: Myth, Power, and Cyberspace.* Cambridge, Mass.: MIT P, 2005.

Morozov, Evgeny. *To Save Everything Click Here: The Folly of Technological Solutionism.* New York: PublicAffairs, 2013.

Movshon, George. "The Video Revolution," *Saturday Review*, August 8, 1970, 50–52.

Murphy, Sheila C. *How Television Invented New Media.* New Brunswick, N.J.: Rutgers UP, 2011.

Newman, Michael Z. *Indie: An American Film Culture.* New York: Columbia UP, 2011.

Newman, Michael Z. "Free TV: File-Sharing and the Value of Television." *Television and New Media* 13, 6 (November 2012): 463–479.

Newman, Michael Z. "To All the VCRs I've Loved Before." *Zigzigger*, August 6, 2013, http://zigzigger.blogspot.com/2013/08/to-all-vcrs-i-loved-before.html.

Newman, Michael Z. and Elana Levine. *Legitimating Television: Media Convergence and Cultural Status*. New York: Routledge, 2012.

Ouellette, Laurie. "Camcorder Do's and Don'ts: Popular Discourses on Amateur Video and Participatory Television." *The Velvet Light Trap* 36 (Fall 1995): 33–44.

Papacharissi, Zizi. *A Private Sphere: Democracy in a Digital Age*. Cambridge, UK: Polity, 2010.

Pinch, Trevor J. and Wiebe E. Bijker. "The Social Construction of Facts and Artefacts: Or How the Sociology of Science and the Sociology of Technology Might Benefit Each Other." *Social Studies of Science* 14, 3 (1984): 399–441.

Postman, Neil. *Amusing Ourselves to Death: Public Discourse in the Age of Show Business*. New York: Penguin, 1985/2005.

Russo, Alexander. "Defensive Transcriptions: Radio Networks, Sound-on-Disc Recording, and the Meaning of Live Broadcasting." *The Velvet Light Trap* 54 (Fall 2004): 4–17.

Russo, Alexander. *Points on the Dial: Golden Age Radio Beyond the Networks*. Durham, N.C.: Duke UP, 2010.

Seldes, Gilbert. *The Great Audience*. New York: Viking, 1950.

Sewell, Philip W. *Television in the Age of Radio: Modernity, Imagination, and the Making of a Medium*. New Brunswick, N.J.: Rutgers UP, 2014.

Society for Cinema Studies Task Force on Film Integrity. "Statement on the Use of Video in the Classroom." *Cinema Journal* 30, 4 (Summer 1991): 3–6.

Sontag, Susan. "The Decay of Cinema." *New York Times*, February 25, 1996.

Spielmann, Yvonne. *Video: The Reflexive Medium*. Cambridge, Mass.: MIT P, 2010.

Spigel, Lynn. *Make Room for TV: Television and the Family Ideal in Postwar America*. Chicago: U of Chicago P, 1992.

Sterne, Jonathan. *MP3: The Meaning of a Format*. Durham, N.C.: Duke UP, 2012.

Streeter, Thomas. "Blue Skies and Strange Bedfellows: The Discourse of Cable Television." In *The Revolution Wasn't Televised: Sixties Television and Social Conflict*, edited by Lynn Spigel and Michael Curtin, 221–242. London: Routledge, 1997.

Sturken, Marita and Douglas Thomas. "Introduction: Technological Visions and the Rhetoric of the New." In *Technological Visions: The Hopes and Fears That Shape New Technologies*, edited by Sturken, Thomas, and Sandra J. Ball-Rokeach, 1–18. Philadelphia: Temple UP, 2004.

Tashiro, Charles. "Videophilia: What Happens When You Wait for It on Video." *Film Quarterly* 45, 1 (Autumn 1991): 7–17.

Thompson, Frank. "Life with Video: Big." *Film Comment* (March 1992): 77.

Tomkins, Calvin. "Video Visionary." *The New Yorker*, May 5, 1975, 44–79.

Usai, Paolo Cherchi. "The Unfortunate Spectator." *Sight & Sound* 56 (Summer 1987): 170–173.

Verna, Tony. *Instant Replay—The Day That Changed Sports Forever*. Beverly Hills, Calif.: Creative Book Publishers International, 2008.

Viola, Bill. "Video as Art." *Journal of Film and Video* 36, 1 (Winter 1984): 36–41.

Wasser, Frederick. *Veni, Vidi, Video: The Hollywood Empire and the VCR*. Austin: U of Texas P, 2001.

Weinstein, David. "Captain Video: Television's First Fantastic Voyage." *Journal of Popular Film and Television* 30, 3 (Fall 2002): 148–157.

Wilinsky, Barbara. *Sure Seaters: The Emergence of Art House Cinema*. Minneapolis: U of Minnesota P, 2001.

Williams, Raymond. *Keywords: A Vocabulary of Culture and Society*. New York: Oxford UP, 1976.

Wilson, Jason. "'Participation TV': Videogame Archaeology and New Media Art." In *The Pleasures of Computer Gaming: Essays on Cultural History, Theory, and Aesthetics*, edited by Melanie Swalwell and Wilson, 94–117. Jefferson, N.C.: McFarland & Co., 2008.

# INDEX

2K, 92
20th Century Fox, 39

adult films/videos. *See* pornography
Abscam, 63–64
*All in the Family*, 23, 63
amateur media, 65–70
Amazon, 75, 86
*America's Funniest Home Videos*, 65–67
Ampex Corporation of California, 17, 19, 21, 26
Apple TV, 86
Antin, David, 33–35
Arledge, Roone, 24
authenticity, 3, 58–70, 88, 94

Benson-Allott, Caetlin, 76, 119n1
Betamax, 21, 23, 26, 36–37
Betamax Case, 40–41
*The Beverly Hillbillies*, 64
Bijker, Wiebe E., 116n101
BitTorrent, 75–76, 88
Blu-ray, 88
Boddy, William, 12, 33, 102, 108n4
Bolter, David Jay, 103
bootlegging. *See* piracy
Boyle, Deirdre, 33
Brothers, Dr. Joyce, 37

*CSI*, 69
cable television, ix, 25, 41, 55, 76–78, 88

Caldwell, John T., 117n22
camcorder, 62–70; *See also*, video camera
Canby, Vincent, 37
*Captain Video and His Video Rangers*, 10–12
Carey, James, viii
Cartrivision, 37
celebrity sex tape, 96
Cheshire, Godfrey, 90–92
cinema, convergence with television, 75–77; convergence with television as degradation of cinema, 94; death of cinema discourses, 88–94; digital cinema as turning point in film history, 90; intensified ambiguity in relation to television in the convergence era, 86–88; movies in the home, 42–46, 54–57; persistence of concept in the digital age, 73–77; in relation to early television, 12–13; in relation to video from the 1950s to the 1980s and 1990s, 61; shifting status in response to home video, 39–48; as superior to video, 2. *See also* film; cinephilia
*Cinema Journal*, 59–60
cinephilia/cinephiles, 50–61, 62, 88–94
colorized films, 55
Comcast, 76
convergence, 75–88
*Cops*, 67
Crosby, Bing, 13
cultural status, 3–4, 101–105
cultural view of the medium, 3, 98–105

DVD, 74, 76, 86, 88
DVR, 86. *See also*, TiVo
Dawson, Max, 27
"Death of Movies" think piece, 89–90
democratization of media, 63–70, 81, 93
Denby, David, 87–88
desktop video, 79
digital movie projection, 74, 90–94
Disney, 41

documentary cinema, 68, 96
Dovey, Jon, 68

EVR video cartridge, 26
electrical transcription, 13
Ellis, John, 15
Enzesberger, Hans Magnus, 29
Epstein, Edward Jay, 116n4

"fake camera view," 69
Feuer, Jane, 76–77
film: digital projection of, 74; as a medium, 96; in relation to video as a format for movies, 50–61; use in television production, 13–19. *See also* cinema
*Film Comment*, 55–57
*Film Quarterly*, 55–56, 60–61
film studies, 55, 58–61
film theory, history of, 103. *See also* film studies
flat-panel television sets, 74
format, as alternative to medium, 97–98
*The French Connection*, 39
Friedberg, Anne, 77

GIFs, 100
Gillespie, Tarleton, 118n1
Gillette, Frank, 35
Gitelman, Lisa, 100–101
Gould, Jack, 15–16, 26, 49
Gray, Ann, 48
Greenberg, Joshua, 102, 114n68
Grindstaff, Laurie, 115n93
Grusin, Richard, 103

high-definition (HD) video, 57–58, 73–74, 91–92
Hilderbrand, Lucas, 119n1
Hollywood, 62, 81, 85, 87, 89; as both a film and television industry, 75–76; as synonymous with movies in the 1950s, 12; response to home video, 37–46
*Homicide: Life on the Street* (television series), 84–85
*Homicide: Second Shift* (online series), 84–85
*House of Cards*, 118n34
Hulu, 75

*I Witness Video*, 65–66, 68
*Indiana Jones and the Temple of Doom*, 43
Institute of Contemporary Art (Philadelphia), 34
interactivity, 82–85
the Internet, 79–86
interpretive flexibility, 70, 116n101
iTunes, 75, 86, 88
Ive, Jony, xi

Jameson, Richard T., 56

Kael, Pauline, 54, 88
Kapor, Mitchell, 81
Kawin, Bruce, 60–61
Keen, Ben, 31
Kinescopes, 17–18
King, Rodney, 66–67, 69
Klinger, Barbara, 49
Koppel, Ted, 66–68

LPs, 26
laserdisc, 57–58, 88
legitimacy, 88; of film and television in relation to one another, 62; of television in convergence era, 86, 93–94; in relation to cultural status, 3
Levine, Elana, 16, 108n3
Levine, Les, 33
Lippmann, Walter, 20–21
liveness, 10, 12–16, 23–25, 34, 63

Magnavox Odyssey, 29
Marvin, Carolyn, 107n1
Marx, Leo, viii
*M\*A\*S\*H* (motion picture), 39
*Masterpiece Theater*, 47
McLuhan, Marshall, 32, 76, 102–103
media, in distinction to medium, 95
media rooms, 42
medium: cultural view of, 3–4; definition of concept, viii, 96–105
mediumism, 96
millennials, 87–88
Minow, Newton, 20
Morita, Akio, 28
Morozov, Evgeny, ix
Mosco, Vincent, ix

Motion Picture Association of America (MPAA), 41
movies. *See* film, cinema; video
"Movies on Television" (essay), 54
Movshon, George, 28
MTV, 20, 89
*My So-Called Life*, 69

Netflix, 73–76, 86, 93, 118n34
new media, 1–2; scholarship on, 98; aesthetics, 117n22
news on television, 23

opera in movie theaters, 92

Paik, Nam June, 31, 35
Papacharissi, Zizi, 115n92
*Participation TV*, 31
PC/TV, 81–85
*The Perfect Vision*, 49–52
Pinch, Trevor J., 116n101
piracy, 39–42, 85
platform, as alternative to medium, 97–98
platform agnostic, 87–88
*Playboy*, 47

*Pong*, 29
pornography, 47–48
Portapak, 31. *See also*, video camera
Postman, Neil, 103

Quirk, John, viii

radio, 9, 13–14, 20
*Raiders of the Lost Ark*, 43
Rand Corporation, 77
RCA, 13, 27–28, 44–45
*Reality Bites*, 69
reality TV, 64
remediation, xi, 20, 73, 103
*Revolution in a Box*, 66–68, 70
revolution talk, ix-x, 36–37, 53, 105
Roku, 86
Russo, Alexander, 14

Sarnoff, 13, 27
*Saturday Night Live*, 64
scholarly publishing, x–xi
Scott, A.O., 93
*Seinfeld*, 91
Seldes, Gilbert, 10

SelectaVision, 26, 28
Sewell, Philip W., 107n1
*sex, lies and videotape*, 69
Shales, Tom, 64–65
*Sight & Sound*, 55
*Singin' in the Rain*, 50–51
Society for Cinema Studies, 59–60
Sontag, Susan, 88–89
Sony, 26, 28, 40–41. *See also* Betamax; Betamax Case; Portapak
Sony v. Betamax. *See* Betamax Case
Spigel, Lynn, 102
sports on television, 24
*Star Wars*, 39–40
Streeter, Tom, viii–ix, 25
surveillance video, 63–64, 69

Tarantino, Quentin, 93
Tashiro, Charles, 56
Task Force on Film Integrity, 59–60
"TV as a Creative Medium," 32
technological solutionism, ix, xi

television, 4–5; as background for understanding video art, 30–36; centrality to the cultural status of video, 101; constitution as a medium, 100; convergence with cinema, 75–77; cultural status in relation to film, 62; cultural status in the 1960s, 20–22; in "death of cinema" discourse, 88–94; digital television as improvement, 93–94; digital transmission, 74; distinctness as medium weakened by online video, 86–88; emergence as a mass medium, 7–16; made active/interactive in combination with computers, 81–85; as a means of watching movies, 54–55; as a medium of intimacy and immediacy, 10; status as most powerful mass medium, 70–71; use with networked computer, 77–84. *See also* cable television; news on television; sports

on television; television networks; video

television networks, 28–29, 34, 41, 81; elevation of live broadcasting, 12–14; integration of online promotion and content, 84–85; place within media conglomerates, 76; use of videotape, 18

Thompson, Frank, 57–58

time-shifting, 37–38, 42

TiVo, 28. *See also*, DVR

Tompkins, Calvin, 35

U-matic, 22–23, 37

University Film and Video Association, 60

VCR. *See* videotape recorder

Verna, Tony, 111n18

VHS, 74, 92, 97–100

Video: as authentic medium of representing reality, 63–70; cultural status of, 101–102; as digital media, 2–3; as digital medium, 73–94; as electronic technology, viii; as a format for watching movies, 39–61; as home technology, 25–30; as an improvement on television, 26–28; inclusion of movies and television shows within category, 85–88; as indexical medium, 68–69; as many things, 95–97; as a masculinized medium, 47–50; as a medium of reproduction of films, 53–61; phases of its history, 2–4; as sight component of television, 9; summary of identity over time, 97; as synonym for television, 2; use in teaching film studies, 58–61; use with desktop computers, 79; as a word, viii, 1, 7–9, 30. *See also* television; videotape; videotape recorder; web video

"Video: The Distinctive Features of the Medium" (essay), 33–35

video art, 18, 30–36

video camera, 31, 62–70. *See also* Portapak, camcorder
video games, vii, 18, 29–30, 86
"Video Killed the Radio Star," 20
video on demand (VOD), 74–76, 85–88
*The Videophile*, 48–49
video popcorn, 114n68
"The Video Revolution" (*Newsweek* story), 42–46
videotape, 2; comparison with digital formats, 80–81; history and development, 17–29; uses outside of television production, 22–23. *See also* videotape recorder
videotape recorder: early uses outside of television production, 22–23; in the home video revolution of 1970s and 1980s, 36–50; ideas of future use in the home, 26–30; in Greenberg, *From Betamax to Blockbuster*, 102; as masculine hobbyist technology, 47–50; replacement by digital technology, 74–76; and shift of cinema from public to private, 43–46; use by television networks, 17–18. *See also* videotape
videotex, 78–79
*Video Today*, 49
Viola, Bill, 33
VTR. *See* videotape recorder

Wasser, Frederick, 47
WebTV, 84
web video, 74–76, 84–88. *See also* video
Weinstein, David, 11
Whitney Museum of American Art, 36
Williams, Raymond, ix
Wilson, Jason, 30
*The Wizard of Oz*, 50–52

X-rated movies. *See* pornography

YouTube, 73–75, 81, 86, 94, 101